IMAGES
of America

LACKAWANNA

IMAGES
of America

LACKAWANNA

Gerald L. Halligan and John Koerner

ARCADIA
PUBLISHING

Published by Arcadia Publishing
Charleston, South Carolina

Printed in the United States of America

Library of Congress Control Number: 2010940116

For all general information, please contact Arcadia Publishing:
Telephone 843-853-2070
Fax 843-853-0044
E-mail sales@arcadiapublishing.com
For customer service and orders:
Toll-Free 1-888-313-2665

Visit us on the Internet at www.arcadiapublishing.com

*To Michael Malyak, whose dedication to the preservation
of Lackawanna history and Bethlehem Steel has made
this book possible. We are grateful for his counsel.*

CONTENTS

ACKNOWLEDGMENTS

The process for the creation of a book always involves the selfless contributions of scores of people who want nothing more than to help. You are the angels of kindness who have made this volume possible. Here we extend our heartfelt gratitude.

At Baker Victory Services, Msgr. Paul Burkard, pastor; Beth Donovan, director of public relations; and Walter Smith, director of publications, offered invaluable help in telling the timeless story of Father Baker. Thank you to Erin Grajek, director of public relations at the Buffalo and Erie County Botanical Gardens, for providing material. The archival assistance from the staff at Buffalo and Erie County Historical Society and the staff at the Lackawanna Chamber of Commerce, especially director Michael Sobaszek, were invaluable in giving this book the historical credibility it required. We thank Nicholas D. Korach, superintendent of the Lackawanna City School District, for his willingness to share his archives and writing skills.

At the Lackawanna Historical Association, Romaine Lillis and Bernadine Klaja were indispensable, offering guidance and writing contributions that grace this volume. We also offer sincere appreciations to Lackawanna Public Library director Jennifer Hoffman and Rev. Christopher Coric, pastor, and Sandra Young, secretary, at Our Lady of Bistrica. Special thanks are extended to curator Spencer Morgan and historian Michael Malyak at the Steel Plant Museum for their help in making the museum come alive. Without them, the crucial story of steel in Lackawanna could not have been told here with such power.

Sterling Photography owner Richard Sterling as well as Paul Warthling and Krista Van Wagner at Curly's Grille allowed us to tell the tale of these two local Lackawanna institutions. Michael Duggan, of American Legion Post No. 63, and William Tojek, a historian specializing in the life and military career of Col. John B. Weber, both allowed us to show the patriotism that is an ingrained part of Lackawanna history. We extend a thank you to all of the families who contributed historical information and images. Grateful thanks to Jennifer Lynne Smith for help with the scanning and preparation of the book, and sincere thanks to Kathleen M. Halligan for her extraordinary patience and support. Thank you to all of the Koerner family who showed enormous patience and support.

INTRODUCTION

The overall purpose of this volume is to present a pictorial history of that part of the town of West Seneca, located in Erie County, in the western portion of New York State, that was to become the city of Lackawanna. The photographic images presented herein are accompanied with historical information, facts, and remembrances of citizens of the community. The various chapters contain brief narrations that highlight the people and major events pertaining to the main topics as related to Lackawanna's history. It is not the purpose of this particular book, however, to present a complete history of the city of Lackawanna in detail. The time period reflected is approximately the first half of the 20th century, the years 1900 through 1949.

One of the original 13 colonies, New York became part of the union in 1788 when it ratified the Constitution. Erie County was established in 1821, and the town of West Seneca was established in 1851, although at its beginning the directional term "west" was not part of its official designation. The part of West Seneca that would become Lackawanna was known locally as Limestone Hill because of a natural bed of limestone that formed a ridge running east to west. Over time, Ridge Road, the main road in this vicinity, would acquire its name because of this geographic feature. Other names used for various sections of Limestone Hill, in whole or in part, were Victoria, Stony Point, the third district of West Seneca, and the Lighting District.

While Lackawanna did not become a political entity with its own governmental powers until 1909, events had already occurred within the town of West Seneca that would greatly enhance the young city's reputation as a place of charity and industry.

A small Roman Catholic mission church called Holy Cross was begun in Limestone Hill in 1850, prior to the creation of West Seneca. The little church was soon joined by St. Joseph's Orphanage, which was created to provide a home and care for a growing number of children who were left homeless when parents fell victim to disease, epidemics, and hard times. In 1873, a new church, St. Patrick's, was constructed; it was headed by Rev. Thomas F. Hines. Newly ordained priest Fr. Nelson H. Baker was assigned to the parish in 1876 and reassigned there permanently in 1882. During his time as pastor, Father Baker oversaw the construction of a protectory, infant home, hospital, trade school, and Our Lady of Victory Basilica.

During the end of the 19th century, great changes were being planned for this developing community. With the coming of spring in 1899, certain businessmen of the Buffalo area held meetings at the Buffalo Club on Delaware Avenue to establish favorable conditions for the Lackawanna Iron & Steel Company to finalize plans for relocating its steel plant in Scranton, Pennsylvania, to Western New York. As the word Lackawanna can be interpreted as "a stream that forks," these two forces—the charitable institutions of Father Baker and the new steel industry—together would shape Lackawanna's character and destiny.

The nine chapters of this book will cover many aspects of life in Lackawanna from the perspective of those who lived there during the first 49 years. These will range from early leaders, ethnic groups, churches, and religious and cultural beliefs to politics, sports, and business.

The first chapter, the Limestone Hill Era, chronicles the characteristics of the land and the people who were active in establishing the identity of the area. Highways and railroad lines, along with natural land features, were beginning to determine where the farms and political boundaries would be drawn. The farms of early community leaders such as Nelson Reed and Col. John B. Weber would become prominent in the local historical record.

In the second chapter, Father Baker's Legacy, the life story of the priest known as "the Padre of the Poor"—from his early years to his death and momentous funeral—is respectfully presented. The full impact of this humble man's accomplishments and impact on the city of Lackawanna can really only be appreciated by a visit to his beloved basilica. The anticipation of Fr. Nelson H. Baker's canonization as the first American-born male saint in the Roman Catholic Church sets the tone for the greatest recognition of his work.

Chapter three, Birth of a City, discusses the establishment of the early government and its related buildings and events. Two of the local district leaders who would rise to hold the office of mayor, Robert Reed and John Widmer, are the foundation for this chapter. There is an intention to recognize the challenges that these early citizens had to meet and the scope of their accomplishments in a very short span of years.

Lackawanna Steel Company's coming is presented in the fourth chapter, Industry of Fire and Ore. The marquee business in the city's history brought political, environmental, and distinct social changes. Rather than describing the process of steel production, the images and text model the history of the Bethlehem Steel Corporation's Lackawanna plant as presented by the workers and members of the company's own museum in the basement of the Lackawanna Public Library.

These first four chapters serve as the root of the early Lackawanna story. The subsequent chapters, five through nine, enhance the historical facts with remembrances of local historians, family business owners, and educational leaders along with the treasured photographs of people who simply loved just living in Lackawanna.

These people truly are the Heart of the City, the title of chapter five, which offers a glimpse into the lives of the immigrant families who worked in the plant and established their house of worship characterized by the customs of their origins. In the sixth chapter, Roots of Commerce, the interconnection between daily life and immigrant business ventures cannot be separated in Lackawanna. While these cultural distinctions are carried further in the social and recreational topics that make up the seventh chapter, Social and Civic Interests, the imperative directive of immigrant parents that all their children become educated is very clear in chapter eight, Education and the Arts.

Our final chapter, A Culture of Patriotism, is an attempt to acknowledge the devotion and spirit of those who contributed to—and often give the ultimate sacrifice for—the cherished freedom that America offered all who came to Lackawanna. There is no single source for the images in this book. In that lies its strength. It is the story of those who worked in the plant, cooked the food, prayed in the churches, and reveled in each other's company in the restaurant taverns of this city. It is within the echoes of their memories that this story is being told.

One

LIMESTONE HILL ERA

Even before the town of West Seneca was established, the land west of Abbott Road to Lake Erie was known as Limestone Hill. The natural ridge of limestone rose above the countryside. Its distinct elevation could be seen by travelers moving between Buffalo and Hamburg. The ridge actually traversed the center of the Seneca Reservation. This was a traditional travel path used by the Native Americans to reach fishing and hunting areas near the mouth of Smokes Creek as it entered Lake Erie.

When the town of Seneca was formed on October 16, 1851, by a division of nearby Hamburg and Cheektowaga, Limestone Hill to the west was included within the boundaries. The lands of the former reservation were sold and distributed for the development of farms, with the ridge creating a natural border. From the top of the natural limestone ridge, which is higher than nearby Buffalo, the land to the south could be seen for miles.

Traditional traveling paths developed into wagon roads running east-west, and important intersections were established along the major roads, with Ridge Road being the major highway. North-south travel crossing Ridge Road created notable corners where farms, estates, businesses, taverns, and hotels were placed on these primary routes.

Among the settlers who later would be leaders in the development of Lackawanna were a Dr. Robinson, Richard Caldwell, a Mrs. Prior, Col. John B. Weber, and Nelson Reed. In 1875, the first two railroad lines laid their tracks through the Limestone Hill area. This brought a host of rapid changes to the community, including a burgeoning business district to meet the demands of the newly arrived workers. Concerns abounded, however, about this rapid growth and the need to assimilate these hardworking immigrant laborers who spoke barely a word of English.

By 1909, Limestone Hill was no more. A new city with higher hopes had taken its place.

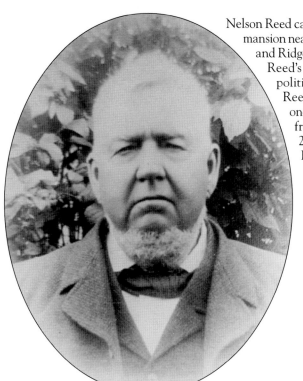

Nelson Reed came to West Seneca in 1833 and built a mansion near the intersection of Hamburg Turnpike and Ridge Road. A three-time town supervisor, Reed's home often served as the center of politics and hospitality for local townsfolk. Reed also saw to the construction of a one-room schoolhouse just down the road from his house that served students for 20 years. (Courtesy of the West Seneca Historical Association.)

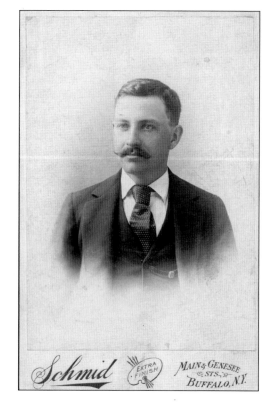

Asa Reed, son of Nelson and Marie Reed, kept a journal of West Seneca from 1882 to 1922. He was one of the leading citizens in the town and served as a volunteer firefighter. With his brothers, Reed was the first to dig gas wells and install gas lines to local homes. (Photograph by Schmid, courtesy of the Knight and Reed family.)

Robert Reed was elected Lackawanna's first mayor on July 6, 1909, and served until December 31, 1910. He appointed Ray Gilson as chief of police and Joseph Bouley as chief of the fire department. They were two of the most influential and successful chiefs in Lackawanna history. (Courtesy of the Lackawanna Public Library.)

The Victory Hose First Volunteer Fire Company is in front of its new fire hall in 1907. At a time of burgeoning construction and few regulations, this company was crucial in keeping the city safe. Many prominent citizens served in this company. They include (first row) Asa Reed (second from left) and Larry Christopherson (fourth from left); (second row) Ray Gilson (fifth from left); (third row) Robert Reed (fourth from left) and Michael O'Mara (fifth from left). (Courtesy of William Tojek.)

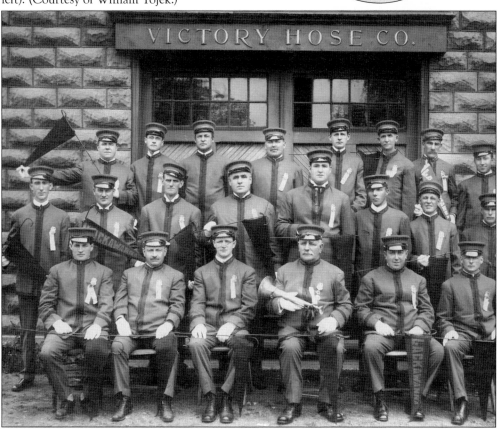

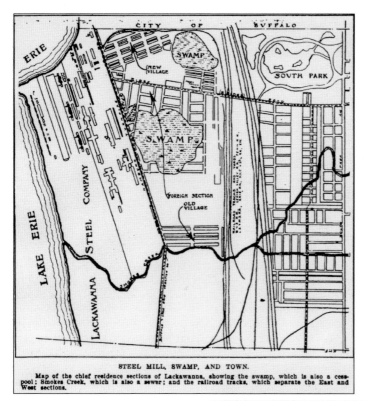

STEEL MILL, SWAMP, AND TOWN.

Map of the chief residence sections of Lackawanna, showing the swamp, which is also a cesspool; Smokes Creek, which is also a sewer; and the railroad tracks, which separate the East and West sections.

This map is found in an extremely comprehensive and critical analysis written in 1911 by John A. Fitch. His article "Lackawanna—Swamp, Mill and Town" is featured in a larger survey of steel companies and cities within six American states. Fitch's first trip to Lackawanna was in 1910, a decade after Lackawanna Steel Company began construction of the plant. (Courtesy of the Buffalo and Erie County Historical Association.)

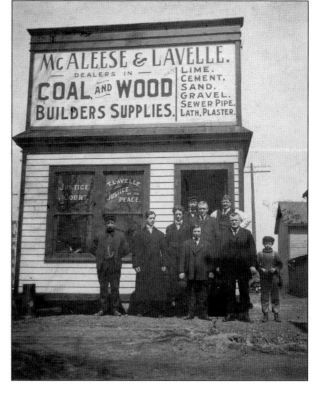

In the early days of numerous towns, it was typical for many buildings to be multiuse sites, such as the McAleese and Lavelle Building on Ridge Road. Its primary purpose was to provide the people of Limestone Hill with a variety of building supplies. Proprietor T. Lavelle, the justice of the peace, held court there before Lackawanna became a city. (Courtesy of the Widmer-Melohusky family.)

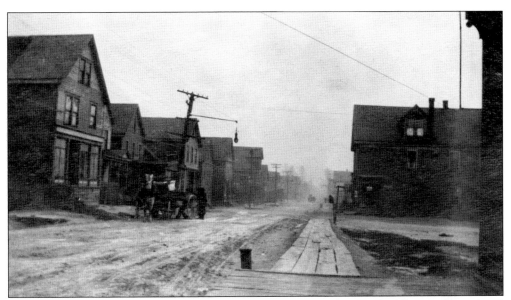

Ingham Avenue was located near the large swamp, north of Smokes Creek Village and connected to Ridge Road. These boardinghouses were typical multiuse structures. Many houses were built half over water with standing water in the cellars. There was no public sewage system in this area. Saloon buildings, prevalent in this vicinity, were often built entirely above stagnant water. (Photograph by George J. Hare, courtesy of the Lackawanna Public Library.)

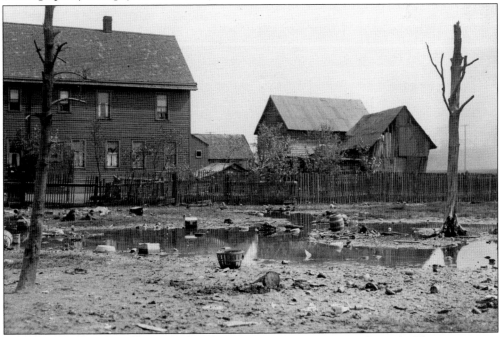

Buildings were accessible by wooden planks with open sewers running alongside. These sanitation concerns and the half-mile-long swamp would be among the challenges taken on by the first administration. Previous government agencies were unprepared for the influx of 15,000 people trying to make a living within the four-square-mile area near the steel plant. (Photograph by George J. Hare, courtesy of the Lackawanna Public Library.)

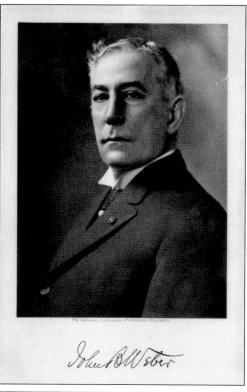

The National Cyclopedia of American Biography

John B Weber

Col. John B. Weber was commander of the 89th US Colored Infantry during the Civil War. Locally, Weber became sheriff of Erie County (1874–1876) and was twice elected to Congress (1885–1889). After serving as First Commissioner of Immigration at the Port of New York (1890–1893), Weber's leadership continued in helping draft the charter to recognize Lackawanna as a city. (Courtesy of the Buffalo and Erie County Historical Society.)

Colonel Weber is with his grandson Blythe Carder and the family dog in front of his mansion in 1903. The white building in the rear was the windmill and pump house, which pumped water to a fountain in a grassy area surrounded by a circular driveway. The mansion is now the rectory of Our Lady of Bistrica. Church archives indicate the home was a station for the Underground Railroad. (Photograph by Sterling Photography Studio.)

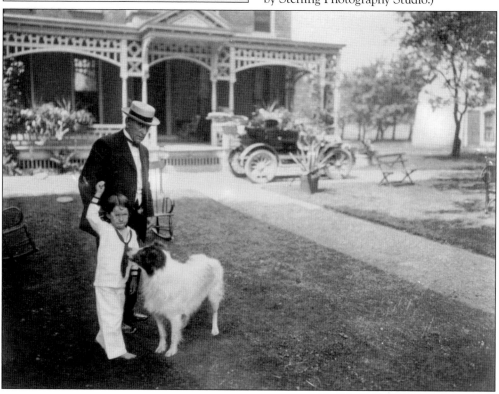

For decades, Martin Road was the site of extensive farms used to grow food to feed orphans and the city's destitute at Father Baker's institutions. This photograph was taken on June 25, 1914, by B. Prudden, a prominent local photographer of the period, and was donated by Martin Road resident Matilda Jaromin. (Courtesy of the Lackawanna Public Library.)

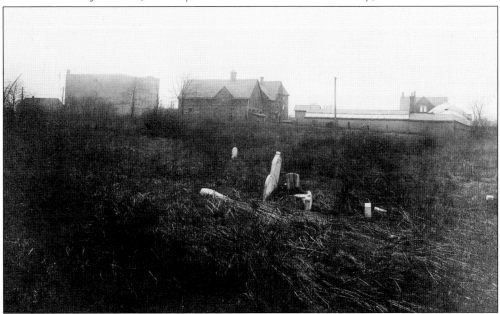

Above is a view of Howard's Cemetery around 1915. A potter's field was established for those unable to pay for services and for victims of epidemics who are buried in a mass grave. The term was first used in the Bible in relation to buying a burial ground for strangers, and it came into use in the United States in the 1800s. This site is the grounds around the Lackawanna Public Library. (Courtesy of the Widmer-Melohusky family.)

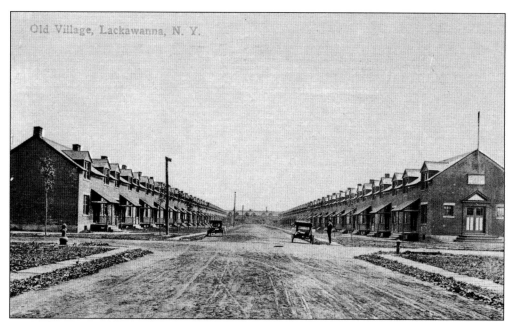

Old Village, Lackawanna, N. Y.

As thousands poured into West Seneca to find employment at Lackawanna Steel, family housing became a necessity. The company built row houses in two major projects on either side of Ridge Road. The first, known as Smokes Creek Village (the Old Village), is pictured here in a 1903 postcard. It contained more than 400 brick apartments. Each had four to five rooms with interior plumbing. (Courtesy of the Lackawanna Public Library.)

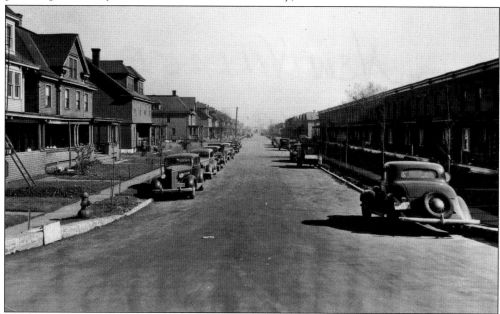

The second housing project for Lackawanna Steel came in 1904. This Ridge Road Village on the Hamburg Turnpike was closer to the plant. Constructed near a swamp and with a new layout, it consisted of single and double houses with multiple rooms, hot water, furnaces, electric lights, and sanitary sewers. Rent averaged less than $18 per month for accommodations that were superior to some in Buffalo. (Courtesy of the Lackawanna Public Library.)

Two

THE FATHER BAKER LEGACY

Perhaps no other name in Lackawanna history conjures up such intense feelings of warmth, nostalgia, and pride than Fr. Nelson Baker. Until his death in 1936, the "Padre of the Poor" helped countless young children and families in Western New York. His infant home, hospital, orphanage, farm, nurses' school, and, of course, Our Lady of Victory Basilica became iconic symbols in the early 20th century, physical reminders of the goodness of humanity. During times of desperate need, orphaned children, single mothers, starving families, or the sick in need of a miracle from this mystical man would come seeking his help. No one was turned away.

This chapter explores the latter years of Father Baker's life, 1900–1936, when his fame began to spread beyond Lackawanna. Increasingly, thousands came to his institutions not just to seek temporary help but also to learn a trade skill or get a basic education. Father Baker was there through it all, overseeing massive construction projects, including the basilica, well into his 80s. The legacies he has left behind are the countless families and the so-called Baker Boys, who left these hallowed grounds with fond memories of a man they called "father" in every sense of that word.

For many years, one of the most effective parenting tools in Western New York was the threat of being sent to Father Baker's for misbehaving. This warning still remains within the memory of many residents in the region. In retrospect, it seems a curious threat given the fact that this man was among the most caring, altruistic humanitarians ever to walk the earth.

Nelson Henry Baker (standing right) was the second oldest of four sons of Lewis and Caroline Donnellan Baker. The family operated a general store near downtown Buffalo and lived in a small home behind it. While his German Lutheran father influenced his keen business sense, it was Nelson's Irish Catholic mother who shaped his strong faith and devotion to the Blessed Mother. (Courtesy of Our Lady of Victory Institutions.)

Nelson Baker had a 30-day enlistment with the Union army during the Civil War. This included active duty outside Gettysburg, Pennsylvania, in July 1863 as well as at the deadly draft riots in New York City just days later. Nelson returned home to start a feed and grain business with his friend Joseph Meyer. After a few years, the business was profitable. Nelson, however, felt another calling. (Courtesy of Our Lady of Victory Institutions.)

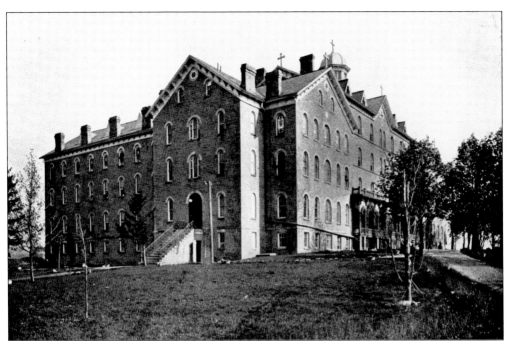

At 27, Nelson Baker entered Our Lady of the Angels Seminary in Niagara Falls (now Niagara University). While older than his fellow classmates, he committed all his energy and enthusiasm to developing his spiritual life. In 1874, he represented the seminary on the first American pilgrimage to Europe. The highlight for many of the pilgrims was a personal audience with Pope Pius IX. (Courtesy of Our Lady of Victory Institutions.)

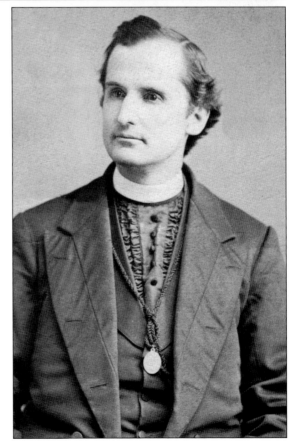

For Nelson Baker, the highlight of the visit was a trip to the shrine of Notre-Dame des Victoires (Our Lady of Victories) in Paris. This small church inspired his lifelong dedication to Our Lady of Victory (OLV). After returning from Europe, he went back to work fulfilling his seminary requirements. On March 19, 1876, he was ordained a priest at age 34. (Courtesy of Our Lady of Victory Institutions.)

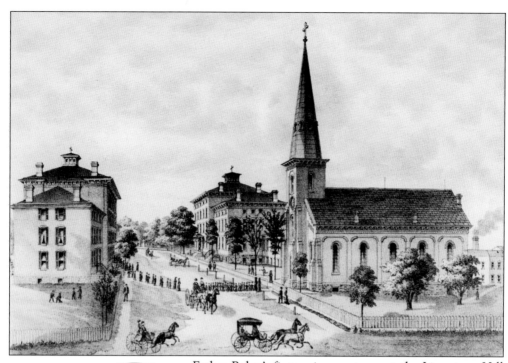

Father Baker's first assignment was at the Limestone Hill Institutions, which included an orphanage, a boys' protectory, and an expanding parish. Fr. Thomas Hines, who was superintendent of the charitable entity, welcomed his new assistant. Hines struggled to make ends meet, and Father Baker's business training was needed to help turn the situation around. (Courtesy of Our Lady of Victory Institutions.)

With the debt continuing to increase, Father Baker was convinced the institutions were doomed to fail. He asked for a transfer and was sent to St. Mary's Parish in Corning, New York. In 1882, Father Baker was called back to Buffalo. At age 40, he was sent to relieve the weary Father Hines as superintendent of what was to become Our Lady of Victory Institutions. (Courtesy of Our Lady of Victory Institutions.)

In his new role as superintendent, Father Baker set out to tackle the enormous challenges he faced with the help of the Sisters of St. Joseph and Brothers of the Holy Infancy. Overseeing the orphanage and the school, the sisters were a fixture at the institutions. They worked hard for their young charges by harvesting, cooking, cleaning, doing laundry, mending, teaching, and mothering. (Courtesy of Our Lady of Victory Institutions.)

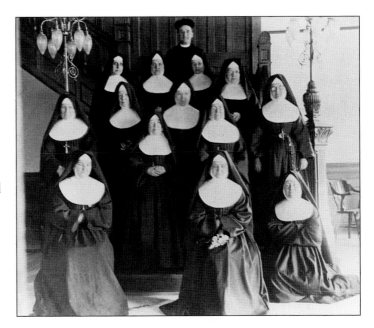

The Brothers of the Holy Infancy oversaw the boys who resided at the protectory. After class each day, the brothers instructed the boys in various trade skills. The sisters and the brothers made great sacrifices for the children, and their work was integral to the day-to-day operations of the parish. (Courtesy of Our Lady of Victory Institutions.)

In 1851, St. Joseph's Orphan Home quickly filled with homeless children. The small, rustic house was later replaced by a large brick structure. By 1901, the number had reached 200 souls. Youngsters came from many states, Canada, and Mexico. Some orphans were put on a train with a tag on their clothing that read, "Father Baker's, Lackawanna, N.Y." (Courtesy of Our Lady of Victory Institutions.)

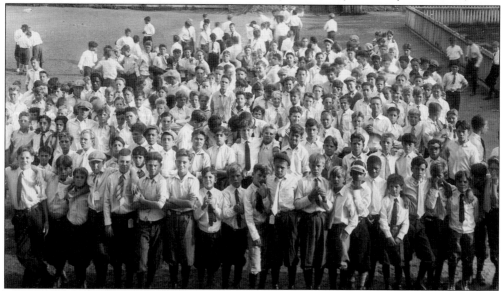

St. John's Protectory housed "willful and hard to manage" boys. Many came from reform school or jail, and close to 400 teens resided at the protectory by 1900. The boys were hardened souls who often did not want to be cared for. Father Baker was committed to giving them more respectable lives. He believed they were "good souls on the wrong path." (Courtesy of Our Lady of Victory Institutions.)

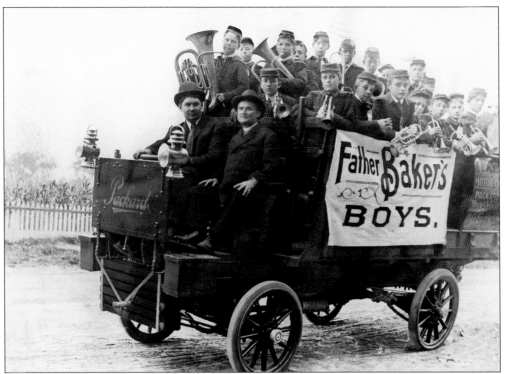

Father Baker was concerned not only for the physical, emotional, and spiritual needs of his residents but their recreational needs as well. The huge complex included areas for swimming and ice-skating as well as various sports. The boys were also involved in theatrical productions and encouraged to play musical instruments. (Courtesy of Our Lady of Victory Institutions.)

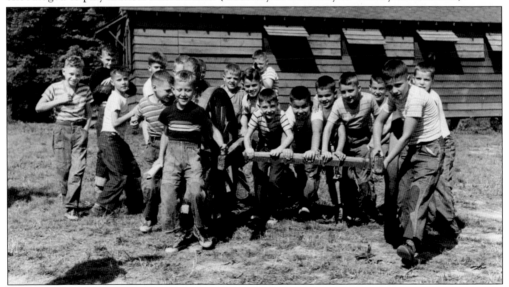

Residents looked forward to weekly movie night in the recreation hall as well as the annual soapbox derbies. Fun was not limited to the complex itself. Father Baker planned regular outings to sporting events, carnivals, the circus, and boat rides. Weeklong trips to a campground were the highlight of summer. (Courtesy of Our Lady of Victory Institutions.)

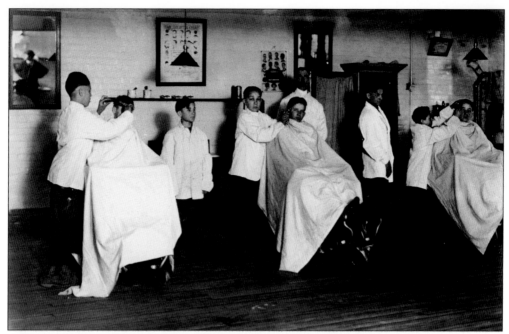

After spending several hours a day in the classroom, the boys from St. John's Protectory turned their attention to trade skills such as painting, carpentry, mechanics, shoemaking, barbering, tailoring, printing, cooking, and baking, among others. (Courtesy of Our Lady of Victory Institutions.)

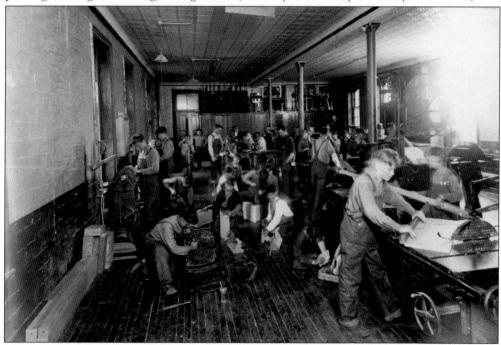

The boys could choose the work that interested them the most. Once they began their tasks, they experienced satisfaction and success, often for the first time in their lives. The boys took pride in their work, and the training laid the foundation for them to become respectable, productive citizens later in life. (Courtesy of Our Lady of Victory Institutions.)

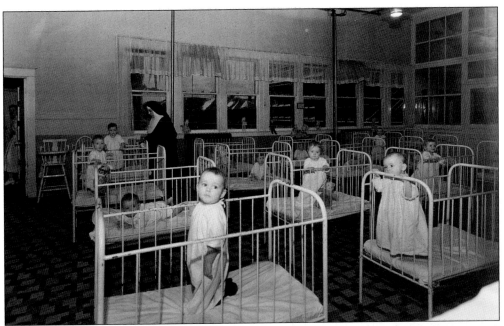

Father Baker had read news accounts that desperate women were taking tragic steps to cover pregnancies out of wedlock. He acted to protect these mothers and innocent children by reaching out to his loyal donors to build the Our Lady of Victory Infant Home, which opened in August 1908. Women came from across the country, some spending weeks there, others months. (Courtesy of Our Lady of Victory Institutions.)

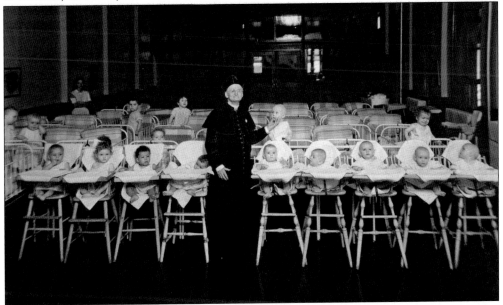

In addition to caring for babies born at the home, a small bassinet inside an entryway safely welcomed children placed there, day or night, with no questions asked. Hundreds of babies filled the infant home at any given time, which was a blessing to countless couples who wished to open their hearts to one of Father Baker's little ones through his adoption program. (Courtesy of Our Lady of Victory Institutions.)

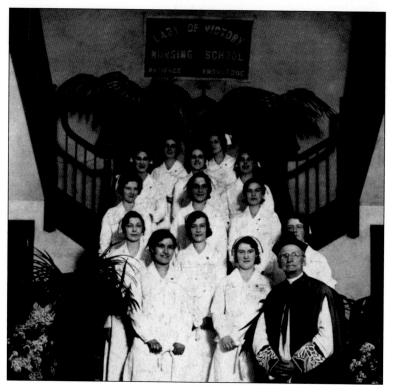

The number of babies cared for at OLV infant home increased so rapidly that Father Baker needed to expand the residence and build a maternity hospital. Soon after its opening in 1909, the maternity hospital was converted to a general hospital to better serve the community, complete with a certified nursing school. (Courtesy of Our Lady of Victory Institutions.)

With mounting bills, Father Baker devised a creative way to raise money. He wrote to Catholic women across the country asking them to join the Association of Our Lady of Victory for 25¢ a year. Members would support the care of the orphaned boys and in turn were promised to be included in the prayers of the priests, sisters, and young wards. (Courtesy of Our Lady of Victory Institutions.)

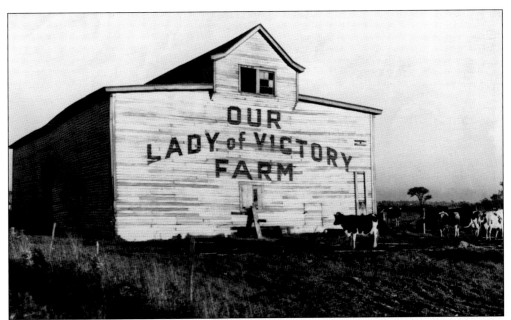

Father Baker's innovative method of member support not only raises invaluable dollars for the OLV institutions today but also helps fund the work of countless nonprofit organizations around the world. Father Baker also successfully drilled for natural gas on the property and developed a working farm to help save money and support his massive City of Charity. (Courtesy of Our Lady of Victory Institutions.)

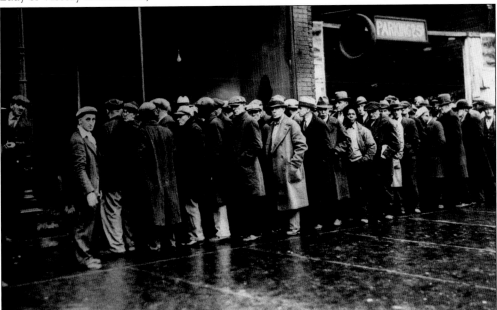

During the Great Depression, Father Baker distributed soup, bread, clothing, shoes, medicine, and even money to hundreds who lined up each day. Between 1930 and 1933 alone, records show that more than 450,000 meals were served. Father Baker also set up boarding homes for families and opened available beds in the complex to individuals needing shelter. (Courtesy of Our Lady of Victory Institutions.)

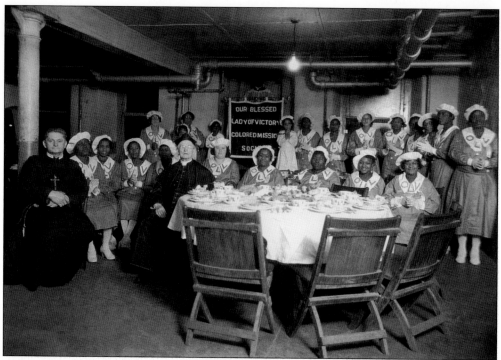

Through his Great Depression soup line, Father Baker met many African Americans interested in the Catholic faith. In the midst of community-wide resistance, he eagerly set up daily religious education classes. Over time, Father Baker assisted more than 500 in converting, and spreading God's word to the black community became one of his proudest achievements. (Courtesy of Our Lady of Victory Institutions.)

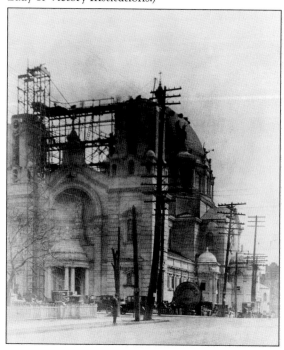

Always giving credit to Our Lady of Victory for all he was able to accomplish, Father Baker felt she deserved a shrine of honor in thanksgiving for all of her intercessions. Still an acute businessman at age 80, he insisted on superior materials and expert artisans but at the most reasonable price. No detail was overlooked, from the grand murals to the smallest decoration. (Courtesy of Our Lady of Victory Institutions.)

The craftsmen were willing to stop at nothing in order to please the assertive but humble priest. After five years of construction, the Renaissance structure with French Baroque artwork was complete. Devotion to the Blessed Mother was at every turn, and the exquisite details and endless beauty of the shrine were simply breathtaking. (Courtesy of Our Lady of Victory Institutions.)

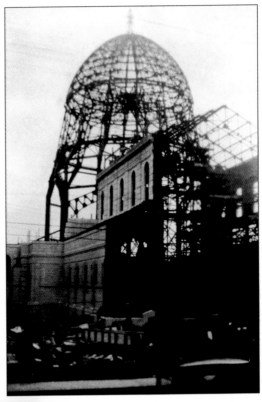

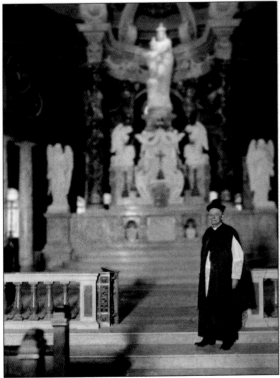

Father Baker celebrated the first mass at Our Lady of Victory Shrine on Christmas Eve 1925. The shrine was personally consecrated by Cardinal Patrick Joseph Hayes, Archbishop of New York, on May 25, 1926. But Father Baker's dream was truly realized when, by official decree, Pope Pius XI named the shrine a minor basilica on July 26 of that same year. (Courtesy of Our Lady of Victory Institutions.)

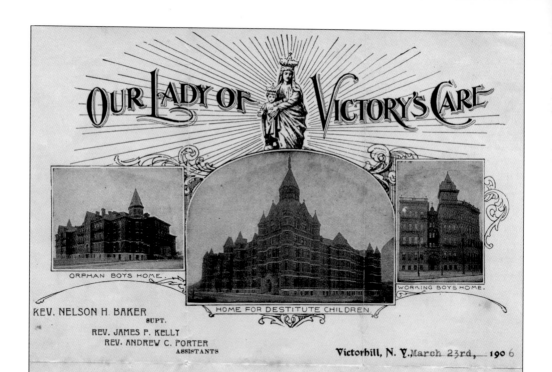

OUR LADY OF VICTORY'S CARE

ORPHAN BOYS HOME.

HOME FOR DESTITUTE CHILDREN.

WORKING BOYS HOME.

REV. NELSON H. BAKER
SUPT.
REV. JAMES F. KELLY
REV. ANDREW C. PORTER
ASSISTANTS

Victorhill, N. Y., March 23rd, 1906

My Dear Sir:-

 Allow me to extend to you my sincere and heartfelt sympathy at this moment of your deep bereavement and sorrow, as it has pleased Divine Providence to remove from yourself and your family of little ones, one whom you have held so dear and looked upon as so necessary to carry out the work which God has entrusted in your hands, and we sincerely hope that He will give you the strength to bear nicely this very severe trial, and permit me to remain,

 Very sincerely and sympathetically yours,

Mr. Asa Reed,
 Victorhill, N.Y.

This letter portrays the human kindness and genuine compassion of Father Baker. Asa Reed was his neighbor whose wife died in childbirth. Left behind were five children for Asa to care for. Father Baker understood the depth of this tragedy and the heavy burden on the shoulders of this young father. The priest's busy life did not keep him from sending his personal condolences. (Courtesy of Linda Knight and the Reed family.)

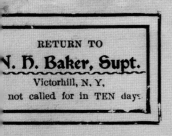

RETURN TO
N. H. Baker, Supt.
Victorhill, N. Y,
not called for in TEN days

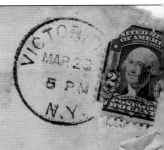

Mr. Asa Reed,

Victorhill,

N.Y.

Father Baker wanted the Post Office Department to rename Limestone Hill. Among his choices were Victory Hill, Victoria, and Victory. Denied at first because of the similarity of the names to other post offices, the name Victorhill was approved. Note that the postal stamps, return address, and mailing address on this envelope indicate the Victorhill Post Office. (Courtesy of Linda Knight and the Reed family.)

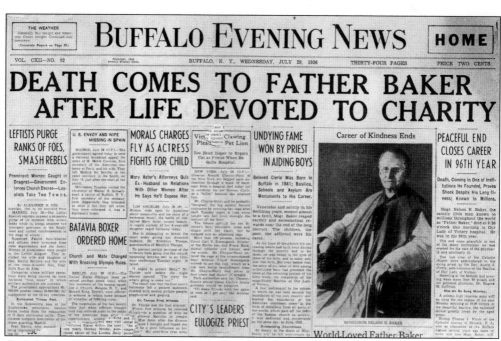

The newspaper headline reads:

BUFFALO EVENING NEWS — HOME

DEATH COMES TO FATHER BAKER AFTER LIFE DEVOTED TO CHARITY

On July 29, 1936, the humble priest who helped hundreds of thousands during his lifetime died at age 94. Newspapers carried huge tributes to outline his tremendous achievements, and messages of sympathy came from around the world. Father Baker's body lay in state in the basilica, and estimates of the number of people who viewed his body reach as high as 500,000. (Courtesy of Our Lady of Victory Institutions.)

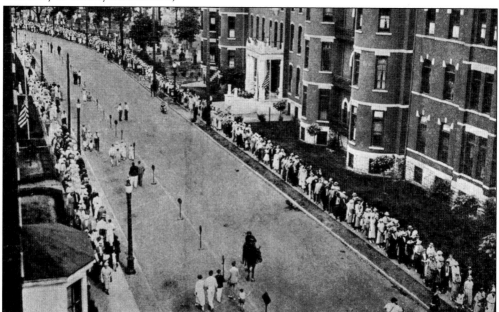

For days, mourners waited for hours in lines more than a half-mile long. Father Baker's funeral mass was held on August 3, and the estimated attendance was 25,000 people. Many assumed he would be buried within the basilica, but, at his will, Father Baker was laid to rest alongside his mother and father in nearby Holy Cross Cemetery. (Courtesy of Our Lady of Victory Institutions.)

Three

BIRTH OF A CITY

Several times in the early 20th century, the New York Legislature was asked to separate Limestone Hill from the town of West Seneca. The issue had to deal with taxes. This bustling hilltop community accounted for 73 percent of the Town of West Seneca's tax base, but most of the tax revenue was being spent elsewhere in the district. Water lines, sewers, and roads badly needed maintenance. Anger reached a fever pitch when a sewer was repaired in West Seneca but paid for by money from Limestone Hill.

A meeting was held on March 2, 1909, in the Victor Volunteer Fire House to raise the issue of seceding from West Seneca to form a new city. On March 6, 1909, another meeting was held during which a unanimous vote was taken in favor of the formation of a new city government. The Lackawanna Steel Company gave its complete endorsement to the idea. Gov. Charles Hughes signed the measure into law on May 29, 1909, and gave the name Lackawanna to the state's newest city.

On July 6, 1909, Robert Reed was elected as the city's first mayor; his term expired on December 31, 1910. That year, the US census reported that this growing municipality had 14,549 residents. For the next 60 years, Lackawanna maintained its high population levels and would not see a population decline until 1970.

Many of the newly arriving immigrants came looking for a better life. They persisted through dogged determination and hard work to try to achieve the American dream. Many worked long hours under dangerous conditions but in the end also created a brand new sense of community.

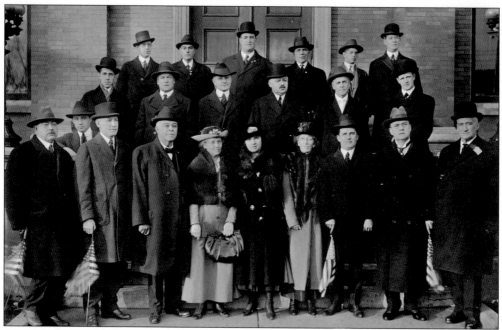

Prominent citizens, businessmen, and city officials pose in front of the new Lackawanna City Hall. These individuals working collectively took on a daunting challenge: transform a formidable landscape in order for a new city to use the chance it had been given to grow. It was an opportunity similar to the one given to the owners of the steel plant. (Photograph by Prudden, courtesy of the Lackawanna Public Library.)

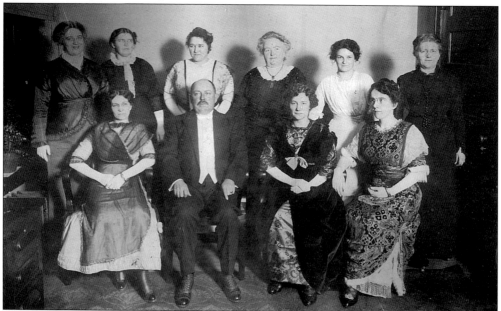

Mayor Robert Reed and his wife entertain some of the wives of the officers of the first administration. In this photograph are, from left to right, (seated) Mrs. Middleton, Mayor Reed, Mabel Reed, and Mrs. Robinson; (standing) Mrs. Briggs, Mrs. Gilson, Mrs. Trevett, two unidentified, and Mrs. Bouley. (Courtesy of the Lackawanna Public Library.)

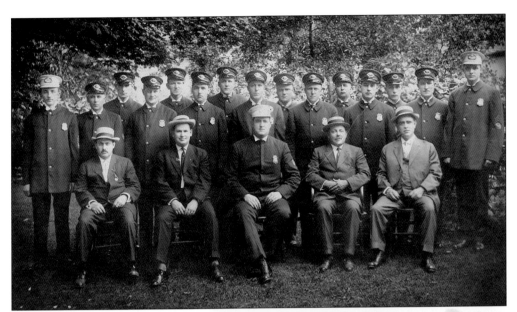

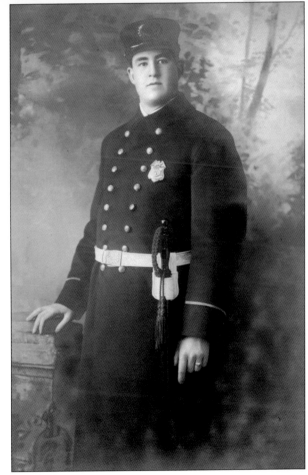

Mayor Robert Reed poses with the new police force in Lackawanna during 1909. In the photograph are, from left to right, (first row) Judge John J. Monaghan, Police Commissioner L.G. Lenham, Chief Ray Gilson, Mayor Reed, and Police Commissioner Peter Smith; (second row) Scout Daley, Mike McLane, Jim Clancy, John Mulqueen, Joe Fennie, Ed Carrell, Elmer Schultz, Bette Davis, unidentified, John Brown, Shirl Collins, Tom Daley, John Curran, John Cawley, and Charles Rose. (Courtesy of the Widmer-Melohusky family.)

Police Chief Ray Gilson was appointed by Mayor Reed following a special election on July 6, 1909. This 1910 portrait is the man whose physical stature and discipline seemed perfect for the rigors of this office. Standing six-foot-seven and weighing 250 pounds, Gilson gained the respect of the community. For example, under his leadership in 1914, only 10 people were charged with major crimes. (Courtesy of the Widmer-Melohusky family.)

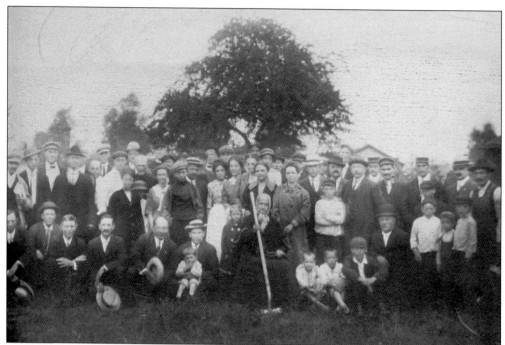

This is the ground-breaking ceremony for the construction of the first Lackawanna City Hall, held in the summer of 1911. The lady holding the spade is Mrs. George Avery, the mother of John Avery. A prominent family in the business community, the Avery family operated a plumbing store in the district in 1905. (Courtesy of the Lackawanna Public Library.)

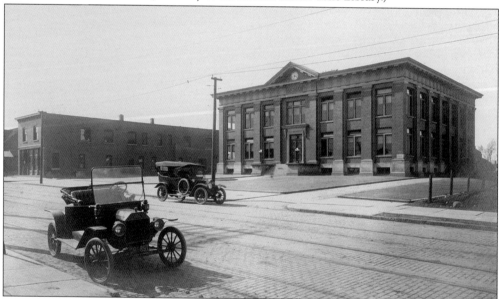

Following a two-year period of construction, the new Lackawanna City Hall was completed in 1914. Like the North Office Building of the Lackawanna Steel Company, this edifice was a symbol of progress in the plant town. By 1916, great advances in public service had been implemented. This included a sewage disposal plant in operation with seven miles of sewers and drains. (Courtesy of the Widmer-Melohusky family.)

John Widmer served as representative councilman in the east administration of the new City of Lackawanna under Mayor Robert Reed. Following the signing of the charter by Governor Hughes on May 29, 1909, a special election was held to establish official leadership positions with the full support of the Lackawanna Steel Company. The poster is indicative of his successful campaign for mayor in 1914. (Courtesy of the Widmer-Melohusky family.)

Mayor John Widmer is seated behind the wheel along with members of his administration during Lackawanna's first Independence Day celebration on July 5, 1915, in front of city hall. In the photograph are, from left to right, City Clerk Michael O'Mara, Mayor Widmer, Third Ward Councilman Joseph Bouley, Second Ward Councilman Thomas Smith, Fourth Ward Councilman Robert C. Avery, and First Ward Councilman Patrick McGovern. (Photograph by R.W. King, courtesy of the Widmer-Melohusky family.)

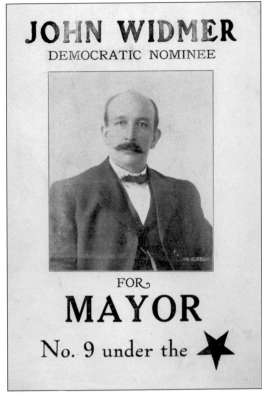

JOHN WIDMER
DEMOCRATIC NOMINEE

FOR
MAYOR
No. 9 under the ★

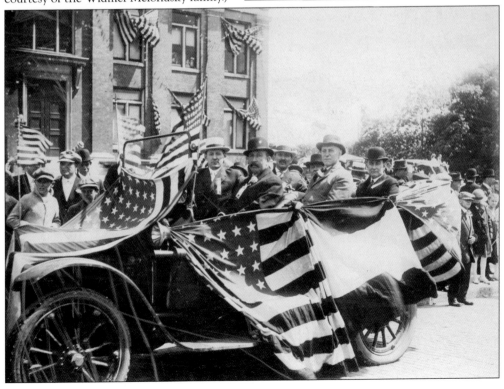

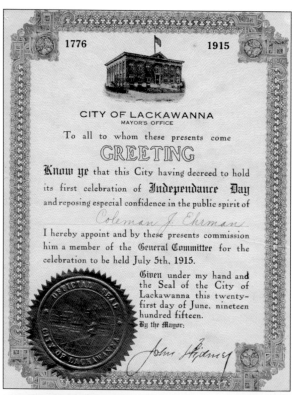

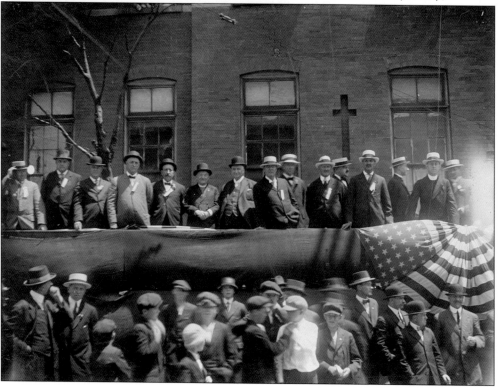

A certificate of proclamation recognizes the appointment of Coleman J. Ehrman to the general committee for the first Independence Day celebration, held July 5, 1915. It shows the actual official seal of the City of Lackawanna and the signature of Mayor John Widmer. (Courtesy of the Lackawanna Public Library.)

This unique photograph shows Fr. Nelson Baker standing among city officials on the reviewing stand at the first Independence Day celebration on July 5, 1915. Father Baker (sixth from the left) is standing next to Mayor John Widmer (fifth from left). This photograph represents both the religious and secular forces that characterized this new city of faith and steel. (Photograph by R.W. King, courtesy of the Widmer-Melohusky family.)

The Lackawanna Steel Company and City of Lackawanna's fundamental investment relationship was with the banking industry and the railroads. In the early years, before the acquisition by Bethlehem Steel Corporation, Lackawanna Steel's chairman of the board, Moses Taylor, was also the director of National City Bank. The Lackawanna National Bank branch was on Ridge Road with new cobblestones and trolley tracks. (Courtesy of the Widmer-Melohusky family.)

This is a view along Ridge Road facing west toward the Hamburg Turnpike in 1914. On the right is the Moses Taylor Hospital at Wilkesbarre Avenue between Ingham Avenue and Holland Avenue. The hospital was completed in 1904 along with other services and benefits, such as a social services department, a YMCA recreation center, and a home nursing service. (Photograph by Prudden, courtesy of the Lackawanna Public Library.)

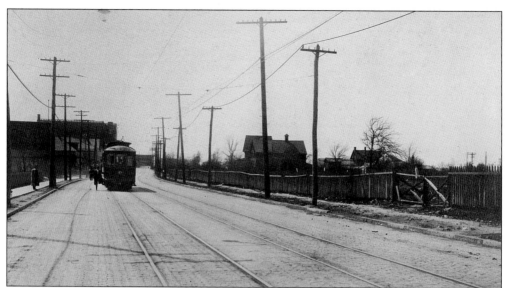

A trolley operator stops along Ridge Road. In the distance is the Hoerner's Hotel. This building was featured at the 1901 Pan-American Exposition in Buffalo and was rebuilt near the south entrance to the botanical gardens. The fence encloses the Howard's Cemetery. In 1920, a referendum approved the relocation of graves so that the land could be used for a veteran's memorial building and public library. (Courtesy of the Widmer-Melohusky family.)

From within Howard's Cemetery, trolley cars can be seen passing by along Ridge Road. Established in 1858 as a final resting place for the unfortunate and unknown deceased, which included many infants, the site had fallen into deplorable conditions. Following lengthy discussions and legal processes, reburial of the remains to a common vault were completed by the end of 1919. (Photograph by Prudden, courtesy of the Widmer-Melohusky family.)

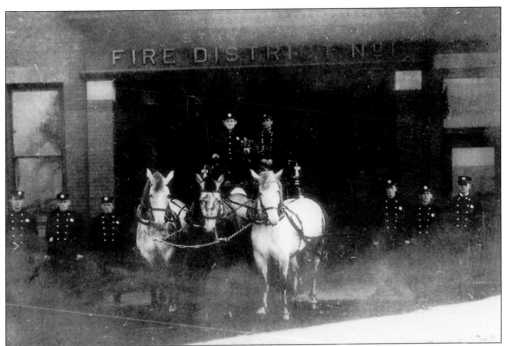

In 1909, this fine team of horses was donated to the newly organized, paid firefighting department during Mayor Robert Reed's administration. The driver of the horses was Romaine Lillis's grandfather Joseph Torba. The names of the horses were Tom, Dick, and Bill. They pulled a hose and chemical wagon out of the Stony Point Fire District House No. 1 on Ridge Road. (Courtesy of Romaine Lillis.)

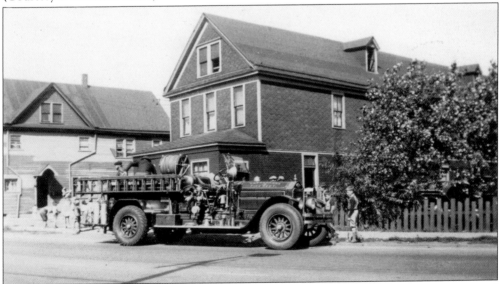

Several years after Fire House No. 1 was established, the Victory Hose Company was converted to No. 2 Fire House Victory Avenue. This company used a single horse-drawn wagon, which was later replaced with a fire truck, seen in this 1924 photograph. The children who are on the sidewalk show typical curiosity with this new, modern fire apparatus of the period. (Courtesy of Lackawanna Public Library.)

On May 29, 1921, a joint memorial service sponsored by American Legion Post No. 63, its women's auxiliary, and the Nancy Lincoln Tent Daughters of Veterans was held in the Lackawanna High School. The following year, a larger Memorial Day program was conducted that included Civil War and Spanish-American War veterans organizations. (Photograph by Charles D. Curtin, courtesy of American Legion Post No. 63 Lackawanna.)

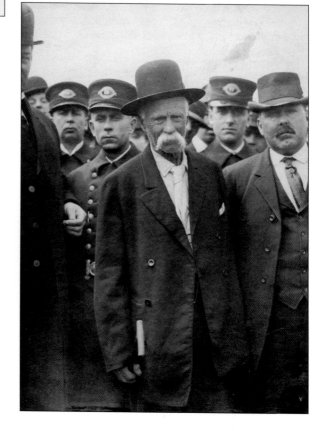

Mayor Robert Reed (right) greets Edward Payson Weston (center, white mustache) upon his arrival in Lackawanna on April 18, 1910. Weston was known as "the Pedestrian." A professional walker, he made several transcontinental trips across the United States. This stop in Lackawanna may be during his 76-day trip from Santa Monica, California, to New York City when he was in his 70s. (Courtesy of the Lackawanna Public Library.)

Four

INDUSTRY OF
FIRE AND ORE

In 1900, the Lackawanna Steel Company relocated from Scranton, Pennsylvania, to the shores of Lake Erie. With easy access to take in iron ore from the Lake Superior mines directly by boat, it seemed the perfect site for a steel mill. The location had some drawbacks, such as nearby swamps and poor transportation links to Buffalo. However, nearby Limestone Hill had plenty of space to expand with the mills.

The general design of the plant was developed by Henry Wehrum, general manager of Scranton Enterprises. Due to poor soil conditions, extensive wood pilings and massive foundations were required to support the tremendous loads of buildings and machinery. The great scale of the entire project and new innovations attracted the attention of steel engineers throughout the world. Cleaning of the site began on May 29, 1900. The first rail was rolled less than three and a half years later on October 20, 1903.

To accommodate the influx of workers, Lackawanna Steel constructed two clusters of company housing, while the rest of the employees lived near the mill in boardinghouses. The company housing units each had electric lights, hot water, and furnaces, and they spread out over as many as eight rooms.

The hardworking spirit of these families who were employed by Lackawanna Steel should never be underestimated. The challenging, sometimes brutal conditions of working in these cavernous mills can be seen on the faces of the men who stare out from the past, pausing during an exhausting moment fixed in time. It is no accident, perhaps, that given these realities, by 1910, Lackawanna had about 200 saloons. That is one for every 75 people.

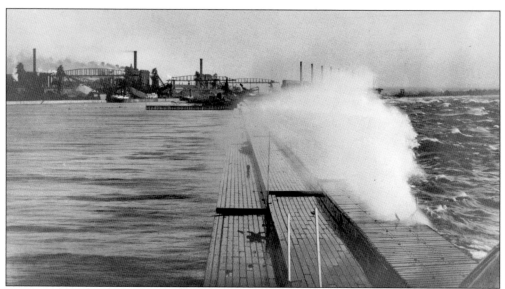

Waves hit the breakwater on Lake Erie near Lackawanna Steel plant in 1903. The wooden structure was constructed in 1899. Water shipment of raw materials and finished products was critical in reduction of costs. Within the organizational structure of Lackawanna Steel, the Seneca Transportation Company was responsible for water shipments. (Courtesy of the Steel Plant Museum of Western New York.)

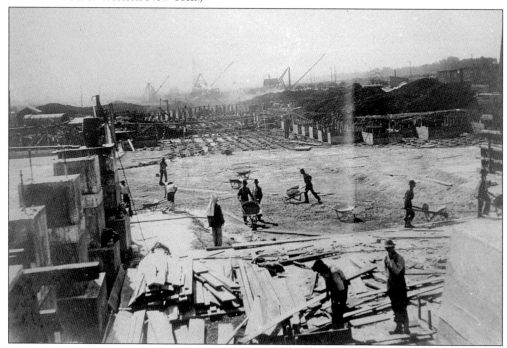

Early construction of the Lackawanna Steel plant began in 1900. Rolling mills were the foundation for converting steel ingots into a finished product. By 1906, there were seven rolling mills completed. Rail mill No. 1, ready by 1903, was a third of a mile long from stripping house to finished product. Here, laborers are working on the rail mill No. 1 foundations. (Courtesy of the Steel Plant Museum of Western New York.)

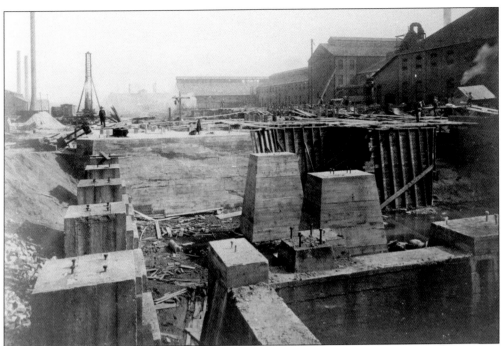

This photograph shows the massive foundations needed for the construction of rolling mill No. 7, also known as a 40-foot blooming mill. This type of semi-finishing mill shapes ingots into a bloom, which is a length of steel having a square or rectangular shape. (Courtesy of the Steel Plant Museum of Western New York.)

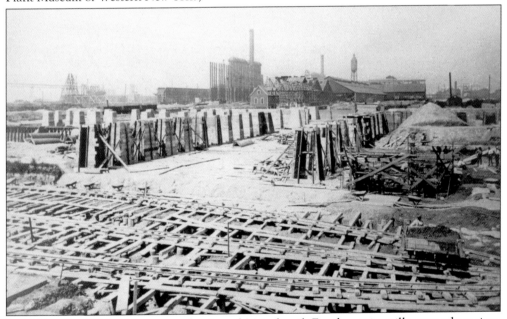

In 1904, rail mill No. 2 began production of 24-inch rail. For the main mills, new adaptations in their design and construction were required for the site. Due to the nature of the land, which was affected by the proximity of Lake Erie, large amounts of fill material were needed for building foundations. (Courtesy of the Steel Plant Museum of Western New York.)

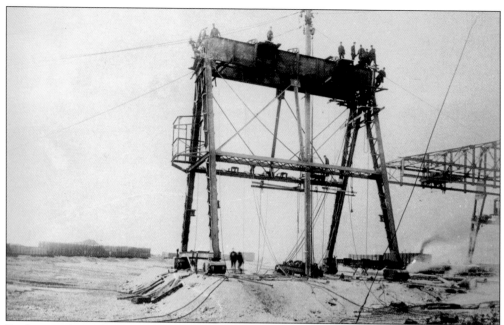

For large-scale production of steel, all material measured in tons had to be lifted and transported simply. A gantry system was used to achieve this by using heavy cranes with hooks and magnets. These were supported by towers on side frames running on tracks. This photograph shows the erection of a "skull cracking" gantry. (Courtesy of the Steel Plant Museum of Western New York.)

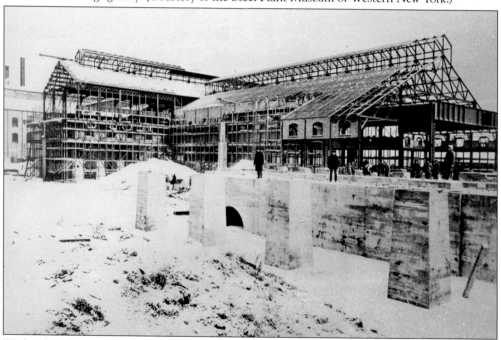

With a long history of steelmaking in the mountains of Scranton, Pennsylvania, this company came to the shores of Lake Erie with experience and an ambitious plan. Seven rolling mills were in production by November 1905. The winters of Western New York were no deterrent for the construction of mill No. 2. (Courtesy of the Steel Plant Museum of Western New York.)

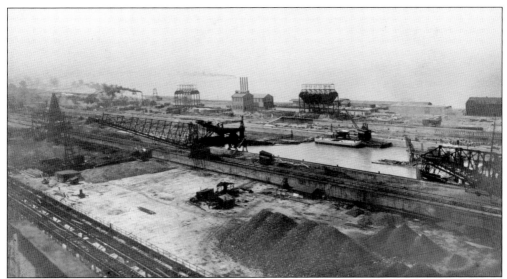

Looking west toward the Lake Erie shoreline, this view shows the ore docks and the dredging of the interim ship canal channels near the coke oven complex. Coke is actually a product of coal distillation that is used in blast furnaces in the steelmaking process. By 1907, Lackawanna Steel Company had constructed 430 ovens. (Courtesy of the Steel Plant Museum of Western New York.)

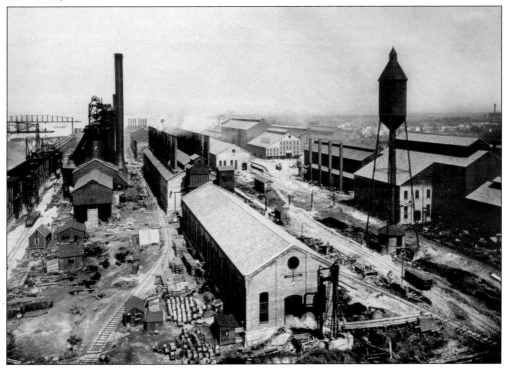

This is a general view of the coke oven batteries looking to the north toward Stony Point near the breakwater. Coke ovens were located on the west side of the ship canal. Much aggregate fill would be added behind the coke oven complex as part of the Lackawanna Steel Company's riparian rights granted by New York State. (Courtesy of the Steel Plant Museum of Western New York.)

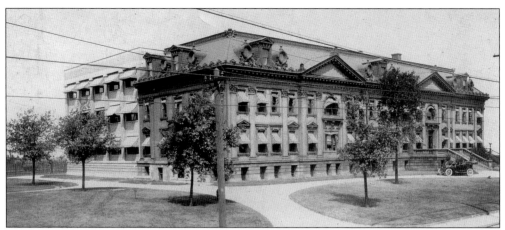

This is the North Office, the administration building of the Lackawanna Steel Company, located on the Hamburg Turnpike. This structure, along with the rest of the plant, captured the imagination of many in the scope of this enterprise. Designed by architect L.C. Holden of New York City, it was one of the first buildings completed in the new plant. The office force brought up from Scranton, Pennsylvania, moved in on September 30, 1901. In addition to the normal business departments, this beautifully designed building originally contained three fireplaces, a billiard room, a reading room, a library, a private dining room, and a private complex with a tub. An ornate cornice sculptured with gargoyles separated the roofline from the walls. A south wing was added in 1910, and the north extension was constructed in 1917. (Both, courtesy of the Steel Plant Museum of Western New York.)

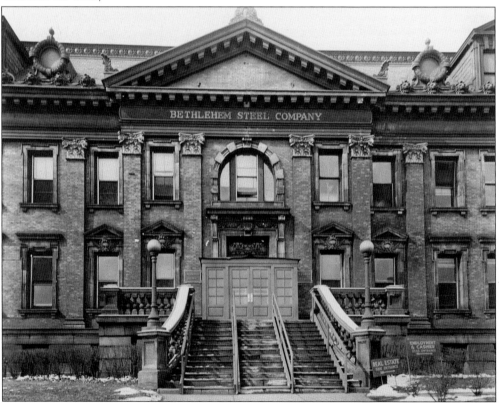

The Welfare Building is decorated on a Christmas Eve. This building provided workers with shower and toilet facilities, sinks, and hanging baskets for work clothes and toiletries. Steelmaking occurred 24 hours a day, seven days a week, so oftentimes holidays were typical working days. With the advent of unions, working a holiday meant additional pay. (Courtesy of the Steel Plant Museum of Western New York.)

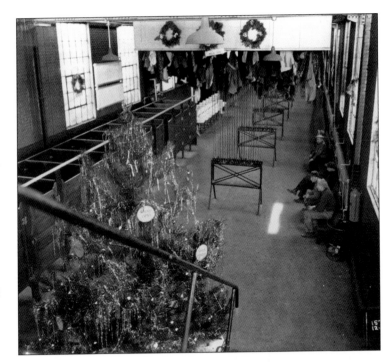

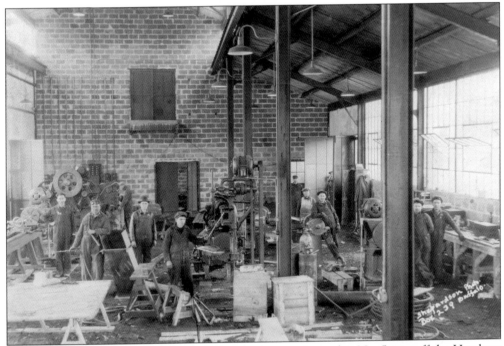

The machine shop at Bethlehem Steel Corporation was located at No. 5 gate off the Hamburg Turnpike. Michael Lillis, a machinist, is standing in the front center with his hand on the press. Others in this 1939 photograph are unidentified. (Photograph by Shepardson Photo, courtesy of the Michael Lillis family.)

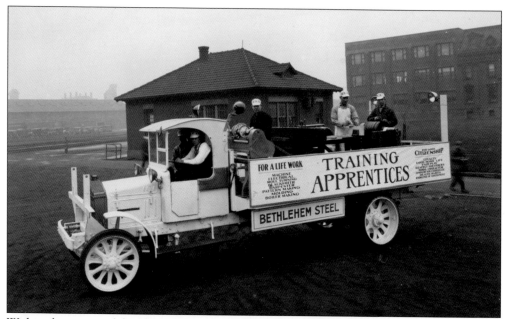

Within the course of the plant operation, a new employee learned his place on the job with an experienced team. In the early years, in order to obtain skilled workers in the trades, complex training programs were established. These apprentices attended special classes once a week and continued skill acquisition while working. It took about four years to complete a program. (Courtesy of the Steel Plant Museum of Western New York.)

This view shows a door-cleaning crew over No. 9 battery. The conversion of raw coal into usable coke was a demanding procedure. Regular equipment maintenance was critical. Also, the management of combustible residual dust and gases given off during the coking process was a priority. (Courtesy of the Steel Plant Museum of Western New York.)

The relocation of the Scranton plant to the shores of Lake Erie was bold. The move from an inland location would create new opportunities to expand into world markets via the Great Lakes. Direct delivery of iron ore and limestone into a ship canal system was a key feature in the new plant's design. (Courtesy of the Steel Plant Museum of Western New York.)

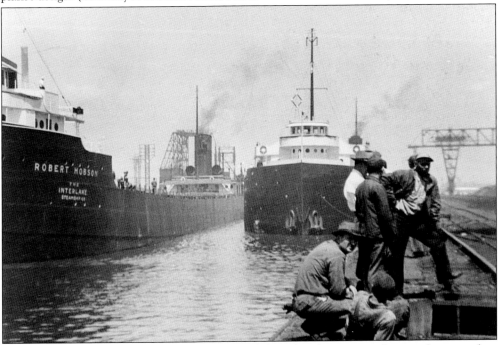

In the plant layout, transportation of raw materials by rail and water complemented one another. Initially, coal was brought up by rail from Pennsylvania. Later, shipments were brought by ship from the Mesabi Range in Minnesota. Both operations required skilled workers in their trades. Joseph J. Kogut (seated left) was a foreman on the docks at Bethlehem Steel in the 1943. (Courtesy of Gene Kogut.)

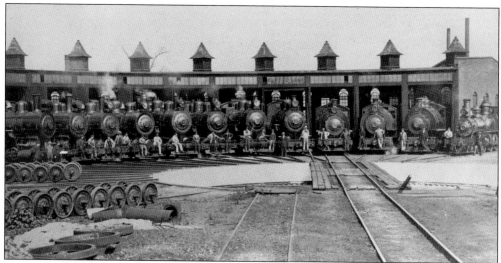

In general, steel companies maintained strong business relationships with railroads in order to receive favorable rates and consideration for primary routes. This factors in both transportation for raw materials and delivery of finished products. The South Buffalo Railway roundhouse is pictured here in 1908. It was located behind the Smokes Creek Village, south of Ridge Road. (Courtesy of the Steel Plant Museum of Western New York.)

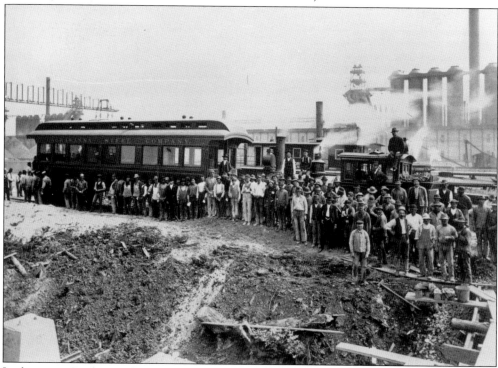

Lackawanna Steel created innovative machinery and made engineering advances. However, even changes in technology could not replace the knowledge and accumulated experience of many steelworkers and supportive trades. Here, construction workers are gathered around the pay car at the coke ovens. In the background to the left is a Hulett crane unloader, and blast furnaces are visible at the right. (Courtesy of the Steel Plant Museum of Western New York.)

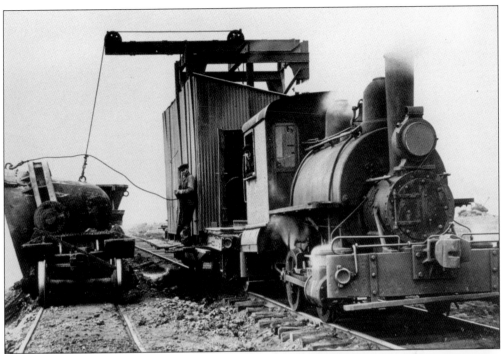

Slag is the water material leftover in the making of steel during the reduction of ores. In the early days of the city of Lackawanna, it was used as fill material in the construction of roads. Here, an employee is operating a pull cable attached to a dump container on a disposal site known as "the hill." (Courtesy of the Steel Plant Museum of Western New York.)

South Buffalo locomotives, narrow-gauge engines, track cranes, slag cars, ingot buddies, submarine cars, and other special equipment all made railroading a unique experience in the plant. This unidentified railroad employee is holding an oilcan next to a locomotive. (Courtesy of the Steel Plant Museum of Western New York.)

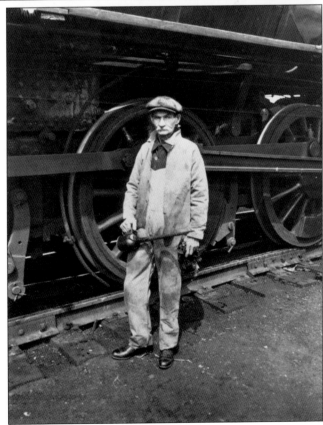

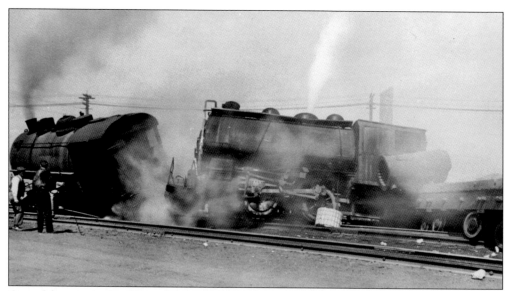

One of the principal rail lines that moved material into and from the rolling mills was the South Buffalo Railway. Working on the railroads could be as dangerous as working as a filler on top of the blast furnaces. This photograph captures two narrow-gauge locomotives colliding near a stone house in the 1940s. (Courtesy of the Steel Plant Museum of Western New York.)

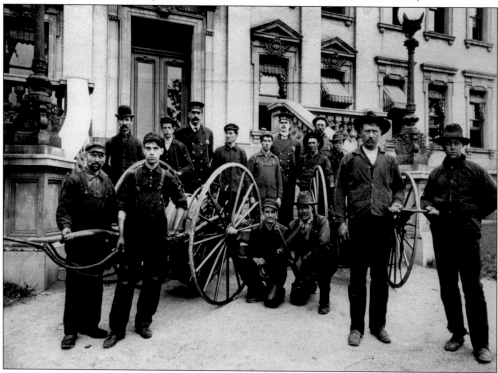

Police and firemen employed by the company were provided right from the start of the plant. Initially, millworkers doubled as firemen, but later, a separate full-time fire department was established. Pictured here is the fire department of Lackawanna Steel Company in front of the main administration building in 1904. (Courtesy of the Steel Plant Museum of Western New York.)

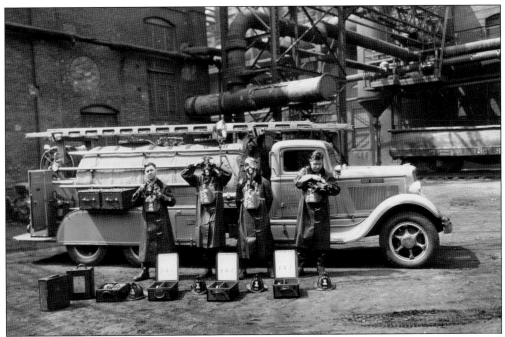

As Bethlehem Steel Corporation's innovations in steel production increased, so did the advances in firefighting methods. Much of this was based on fire suppression being researched in the coalmining industry. In this 1940s drill, the firemen are demonstrating use of gas masks, a very vital piece of equipment used at the plant. (Courtesy of the Steel Plant Museum of Western New York.)

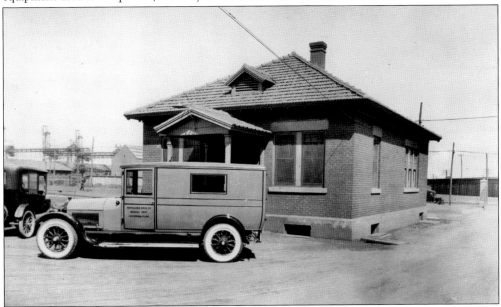

Steelmaking is a hazardous operation. Traditionally, long hours of hard physical labor near machinery with molten ores increases the chance of injury or death. Some technological advances removed many dangerous jobs. However, in 1911, a safety department was formed to help reduce and prevent accidents. This photograph shows an ambulance near the medical clinic at No. 1 gate. (Courtesy of the Steel Plant Museum of Western New York.)

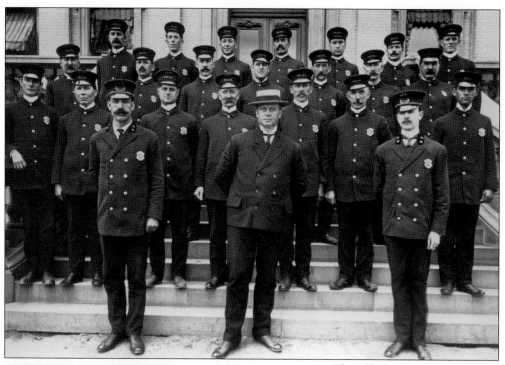

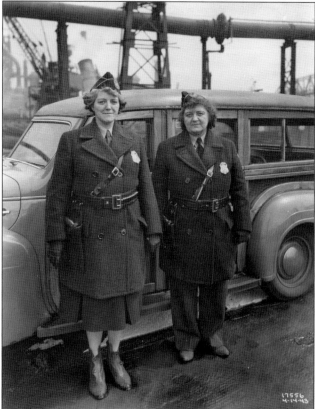

The officers of the Lackawanna Steel Company's plant police pose in front of the North Office building in 1904. Bert Davis was the first fire and police chief. The growth of the plant layout and the round-the-clock operation presented critical security challenges for the plant police. (Courtesy of the Steel Plant Museum of Western New York.)

The Great Depression brought about changes in traditional labor practices. Fueled by economic need and the manpower shortage created by the war effort, women entered the workforce in greater numbers. These unidentified women officers were photographed on April 14, 1943. (Courtesy of the Steel Plant Museum of Western New York.)

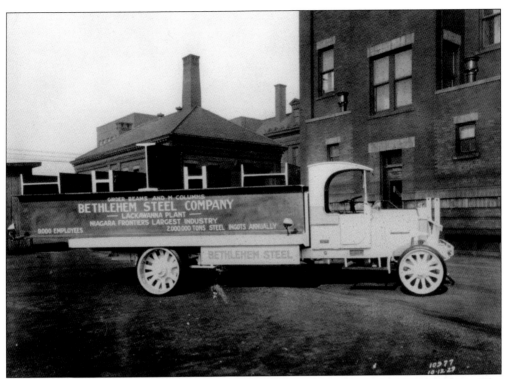

A customized truck from the Bethlehem Steel Corporation features various steel products. The statistics painted on the sides of the huge beam tell the whole story about the prominence of the company at the time. This photograph was taken on October 12, 1929. (Courtesy of the Lackawanna Chamber of Commerce.)

The unique properties of steel make it an ideal material for a broad range of uses. Finished products of the Lackawanna Steel Company included bars, plates, rails, sheets, sheet pilings, and structural shapes. This commemorative piece with engraving is from the first run of steel rail out of the No. 1 rail mill. (Courtesy of the Steel Plant Museum of Western New York.)

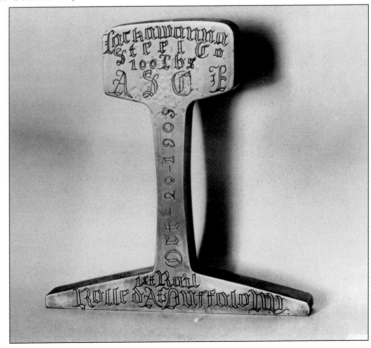

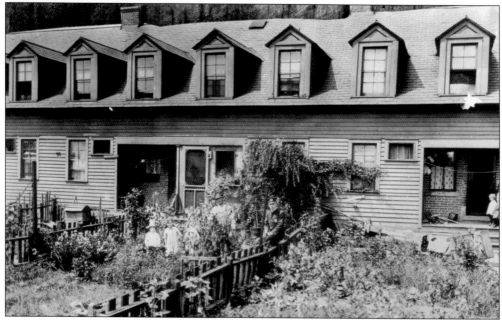

Since the surrounding area of the newly built plant was mostly farmland, very little housing was available for the growing workforce. Lackawanna Steel Company built the first brick row house units south of Ridge Road. It was known as Smokes Creek Village (Old Village). This photograph shows a backyard on Second Street. (Courtesy of the Steel Plant Museum of Western New York.)

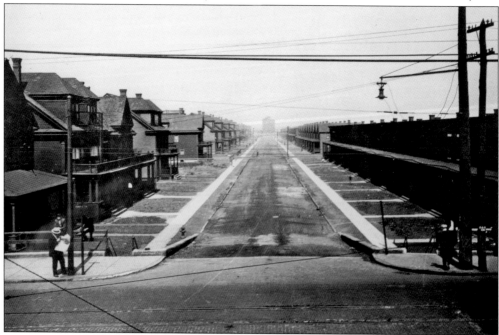

This is the Ridge Road Village, the second of the company's formal housing units, looking north toward the plant. Located north of Ridge Road, it differed from the First Village with the option of detached single and double houses built in closer proximity to the plant. This photograph was taken on October 22, 1941. (Courtesy of the Steel Plant Museum of Western New York.)

These are single houses of the Ridge Road Village (New Village) at the intersection of Fifth Street and the Hamburg Turnpike, which runs parallel to the Lake Erie shoreline. This corner property was originally deeded to the federal government for the South Channel Lighthouse keeper's residence. (Courtesy the Steel Plant Museum of Western New York.)

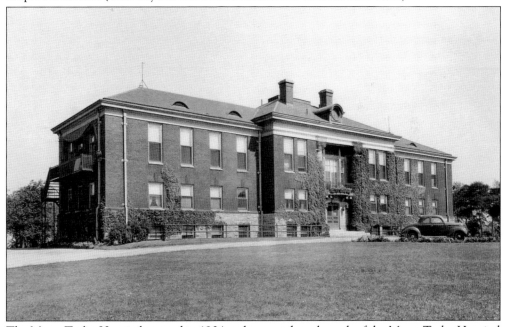

The Moses Taylor Hospital opened in 1904 and operated as a branch of the Moses Taylor Hospital in Scranton, Pennsylvania. This health facility was named for Moses Taylor, a financial industrialist involved in steel and iron manufacturing, railroads, mining, and banking. This photograph was taken on September 21, 1937. (Courtesy of the Steel Plant Museum of Western New York.)

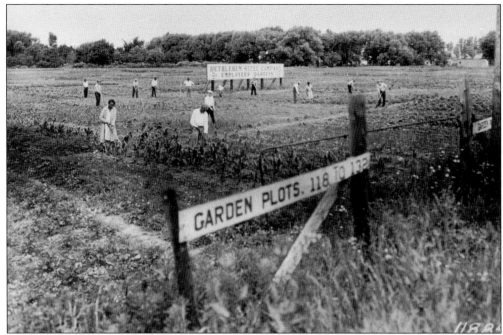

During World War I and on through the 1930s, employees were able to grow their own produce in Victory Gardens on company-owned property. This is the current site the South Office building, near the Ford Stamping Plant. This view is looking west, showing community gardens south of Rush Creek. (Courtesy of the Steel Plant Museum of Western New York.)

Lackawanna Steel Company purchased more than 1,500 acres of land from John Albright's Stony Point Land Company at the end of the 19th century. Not all the land was immediately needed for construction of the steel plant. This allowed the company to use land for company gardens, with plots assigned to various workers. Workers could grow produce for family use. (Courtesy of the Steel Plant Museum of Western New York.)

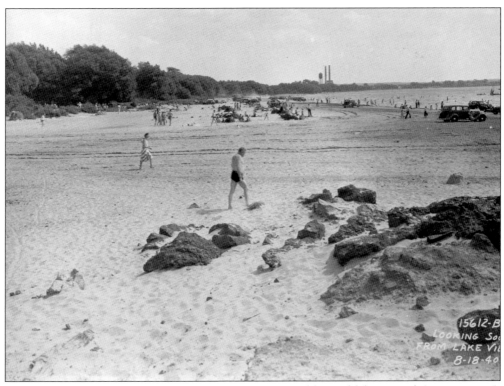

Woodlawn Beach, on the shores of Lake Erie, was owned by Bethlehem Steel Corporation. It was a popular recreational area where many steelworkers and families spent their leisure time. It is remembered for its sandy beach and amusement park with arcade. (Courtesy of the Steel Plant Museum of Western New York.)

In this aerial view of Ridge Road running west toward the Hamburg Turnpike, the Ridge Road Village can be seen in close proximity to the plant. Clearly visible are the slag piles of Buffalo Gravel, just to the east of Lohr Street. Other landmarks are the second Croatian church, Tomaka's Drug Store, and the Ridge Theater. (Courtesy of the Steel Plant Museum of Western New York.)

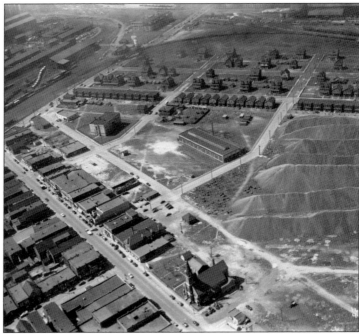

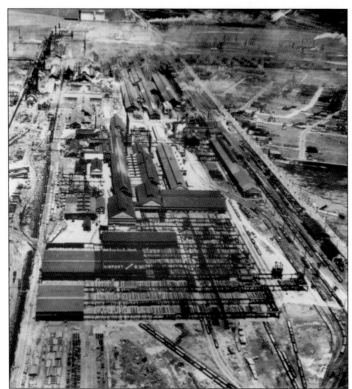

The scale of the Bethlehem Steel Corporation's Lackawanna plant is apparent looking northward along the Hamburg Turnpike in the late 1940s. In the foreground are the storage beds just south of the rolling mills complex. Significant innovations to the layout, such as the addition of hot and cold strip mills, signaled the shift away from Lackawanna Steel's original design and production goals. (Courtesy of the Steel Plant Museum of Western New York.)

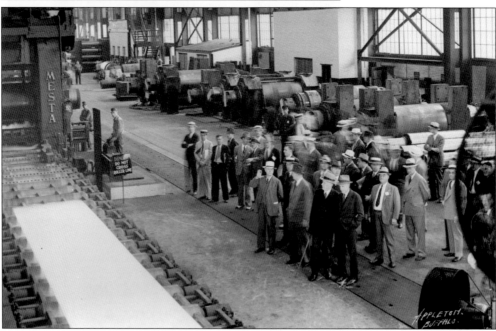

In 1936, founder Charles Schwab (front center, with cane) and president Eugene Grace (front right) visit one of the new strip mills. Upon Schwab's death in 1939, Grace assumed the chairmanship. The subsequent change in management led to a 27-year period of leadership, stability, and profit. (Courtesy of the Steel Plant Museum of Western New York.)

Five

HEART OF THE CITY

When many people look back at their lives, often some of the most important events that they hold dear relate to their family's ancestral culture, its customs, and places of worship. Weddings, funerals, baptisms, and graduations, along with the weekly act of worship as a community in a free country, make spiritual places a source of emotion carried in the heart.

The people of Lackawanna are diverse in their ethnicity yet maintain a common heritage that has many customs and characteristics drawn from many countries. Even within the culture of the steelworkers, there existed a palpable bond among them that was forged in the fire of the difficult work in the plant.

This community can claim such a large variety of religious denominations of worship that other communities of a similar demographic size would find hard to match. During the first 49 years of its existence, Lackawanna's notable faiths included Roman Catholic, Baptist, Presbyterian, and Protestant. With the National Shrine of Our Lady of Victory Basilica (1925) as the centerpiece of the crossroads of Ridge Road and South Park Avenue, other churches were built in areas with concentrations of particular immigrants, such as those from Croatia, Serbia, and Poland. Some broke ground at multiple locations, and some buildings were home to different denominations throughout this period of time.

Some of the specific congregations, with the years they were established, include the Roland Methodist (1899), Queen of All Saints (1902), St. Barbara's Parish (1902), St. Michael the Archangel (1910), Magyar Presbyterian (1913), St. Mark's AME Zion Church (1917), St. Stephen's Serbian Orthodox (1917), Our Lady of the Sacred Heart of Jesus Croatian Parish (1917), Bethel African Methodist Episcopal Church (1923), Second Baptist Church (1927), Holy Trinity Polish National Catholic Church (1929), and the Church of God in Christ (1942).

Although Lackawanna attracted a vast array of nationalities, languages, and religious practices, the people of the plant town all shared a dream. They struggled to establish a successful livelihood to support their families and become proud Americans while maintaining a respect for where they had come from.

The original St. Barbara's Church is surrounded by businesses on Ridge Road and Caldwell Street in 1914. Polish immigrants under the guidance of Rev. Dr. Piotr Szulc saw to the construction of a combination church and school complex in 1905. Later, with many workers living closer to the plant, a second church, St. Hyacinth's, was built "back of the bridge." (Courtesy of the Lackawanna Public Library.)

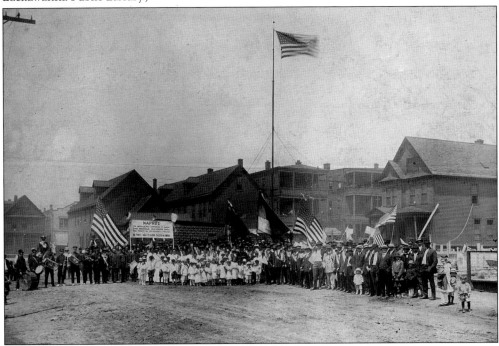

As the city's ethnic groups planted roots in Lackawanna, many organized church congregations and built houses of worship. The Serbian immigrants broke ground on August 12, 1917, for the St. Stephen Serbian Orthodox Church cornerstone ceremonies. The sign reads *napred*, or "progress," at the new Church Street site in the First Ward between Gates and Wasson Avenues. (Courtesy of Nicholas D. Korach.)

St. Patrick's Parish Church was the original building that served as the foundation for Fr. Nelson H. Baker's ministry in the Limestone Hill area. In this church, as superintendent of the orphanage and as pastor, Father Baker received his inspiration to meet the temporal and spiritual needs of not only the children but also of the entire Lackawanna community. (Courtesy of the Reed family.)

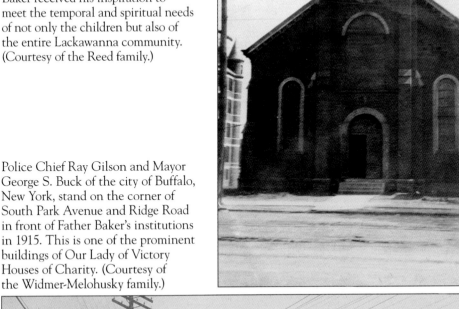

Police Chief Ray Gilson and Mayor George S. Buck of the city of Buffalo, New York, stand on the corner of South Park Avenue and Ridge Road in front of Father Baker's institutions in 1915. This is one of the prominent buildings of Our Lady of Victory Houses of Charity. (Courtesy of the Widmer-Melohusky family.)

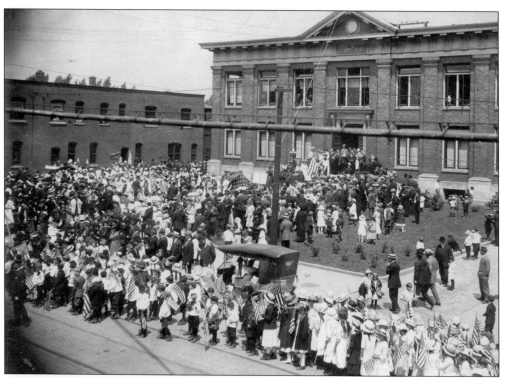

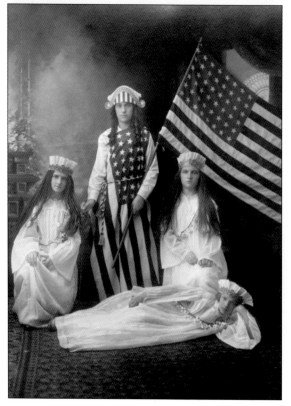

On Labor Day 1919, residents of Lackawanna displayed a salute to the League of Nations on a grand scale. It was a celebration of the spirit of cooperation while acknowledging the individual character of all cultures that had come to this steel community. Participants gathered in front of city hall. Sarah Ehrmann was chairwoman for this memorable event. (Courtesy of the Lackawanna Public Library.)

This photograph, taken in Prudden Studios at 517 Ridge Road in Lackawanna, shows four immigrant children proudly displaying their new American heritage. Lackawanna's League of Nations celebrations of 1919 highlighted the city's ethnic groups as well as American patriotism. Becoming naturalized American citizens was very important to immigrants, and patriotism, along with service to their new country, was always encouraged. (Courtesy of Nicholas D. Korach.)

Two boys, August Twist (left) and Walter Widmer, pose on a horse in 1910. This was a time when a horse stable was more likely to be located in the backyard than a garage. The picture was taken on Southside Parkway. It was part of the parkway system designed by Frederick Law Olmsted for the City of Buffalo preceding the Pan-American Exposition of 1901. (Courtesy of the Widmer-Melohusky family.)

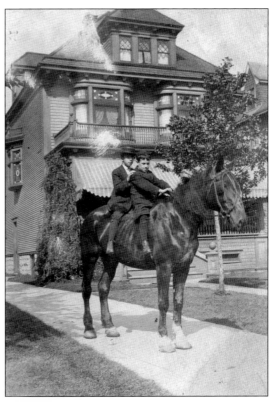

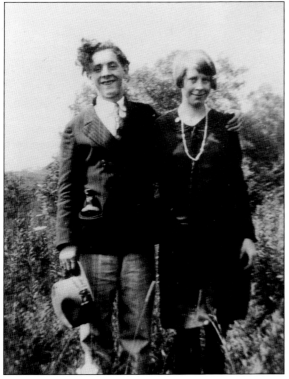

There is quite a difference between the clothes of these teenagers in the late 1920s compared to those of teenagers today. Brother and sister Frank and Rose Schwed, ages 17 and 16, lived on O'Dell Street across from the Roosevelt School. One can only wonder about the dreams and aspirations hidden within the smiles of these young siblings. (Courtesy of Romaine Lillis.)

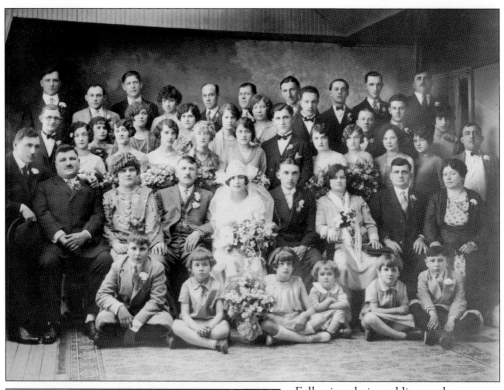

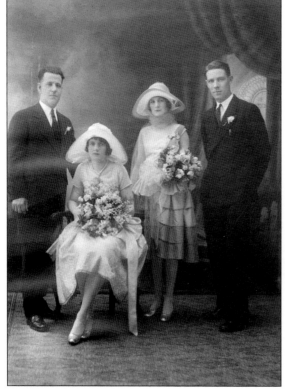

Following their wedding at the Stephen's Serbian Orthodox Church, Peter Malyak and Anna Stipanovich gather for a family photograph at Prudden Studios on May 9, 1926. As was the custom of their culture, after the vows were exchanged, the wedding party paraded around in the streets surrounding the church. (Photograph by Prudden, courtesy of Michael Malyak.)

Francis "Curly" Warthling (left) married Mae Keefe (seated) in Lackawanna in 1927. Their families had followed the move of the steel plant from Pennsylvania. Francis was born in Scranton, and Mae had lived in Waverly. She had worked for F.M. Burt in the Larkin Company building in Buffalo. The maid of honor is Lilian Dempsey, but the best man is unidentified. (Photograph by Prudden, courtesy of the Warthling family.)

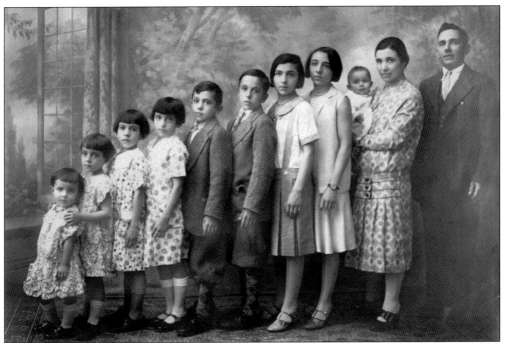

This family photograph was taken at Prudden Studios at 517 Ridge Road, Lackawanna, in 1930. Pictured is the family of First Ward merchants Janko and Ana Budimirovich. The children, from left to right, are Sylvia, Draga, Eva, Mildred, Bernard, Mitch, Mary, Anne, and baby Helene. (Courtesy of Nicholas D. Korach.)

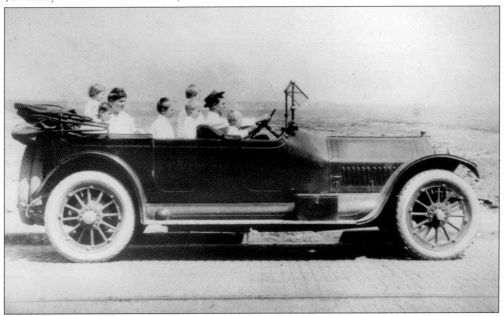

A drive along Lake Erie is taken by Mr. and Mrs. Martin Soda with six of their eight children. Soda operated a bar and grill on Warsaw Street called Murphy's Warsaw Grill. The model of the automobile is unclear, but Soda often used it to take family and friends to funerals. (Courtesy of Clara Balcerak.)

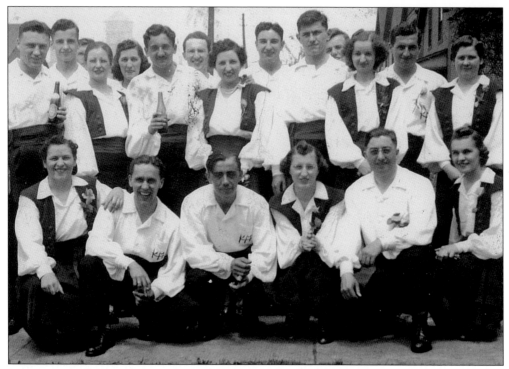

First-generation Americans—sons and daughters of ethnic immigrants—were human bridges between cultures of the old country and new country. Many organized civic, cultural, and religious clubs of common interest and goals. Young American Serbs founded the Kosta Manojlovich Serbian Singing Society in 1939. This photograph was taken on Gates Avenue in Lackawanna. Note the smokestacks of Bethlehem Steel Corporation in rear. (Courtesy of Nicholas D. Korach.)

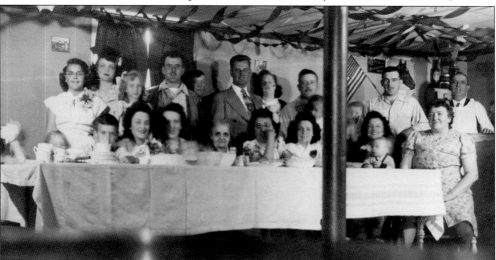

Celebrations were a big part of family life for the Ljuba and Peter Barbic family of Wilson Street in Lackawanna, who emigrated from Croatia by way of Pennsylvania in search of a job in the steel mills. Pictured are Ljuba and Peter in the center surrounded by their children, in-laws, and grandchildren. Most of their male children and sons-in-law also worked in the steel plant. (Courtesy of Linda Kovacs.)

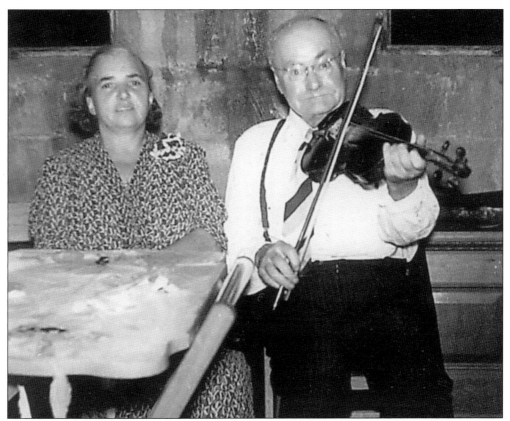

Pictured are Margaret and Philip O'Connor, also known as "Aunt Maggie" and "Uncle Phil," who resided for many years at 2811 South Park Avenue with their 10 children. Philip often played his fiddle for family and friends. The living room carpet was rolled up to allow for dancing, and an Irish "hooley" (party) proceeded to take place. (Courtesy of Romaine Lillis.)

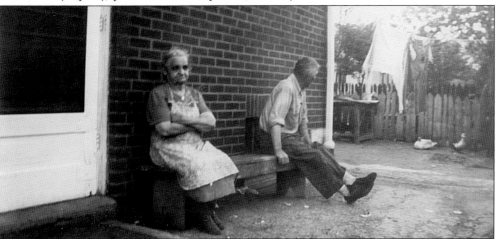

Ljuba and Peter Barbic are sitting on a bench in their yard on Wilson Street in Lackawanna. Lillian Barbic Manka took this picture of her parents in 1948 and called it "after a hard day's work." They were Croatian immigrants and came for jobs in the steel mills of Lackawanna. The Barbics raised nine children. (Courtesy of Linda Kovacs.)

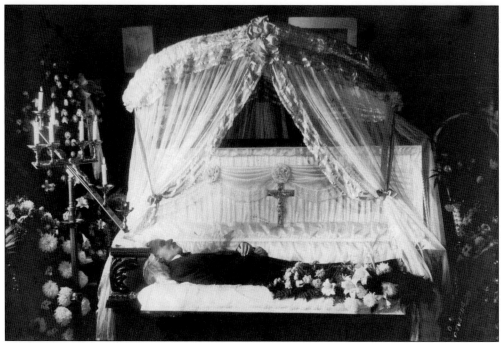

This is the funerary portrait of Josef Domowicz, who arrived from Poland in the late 1800s. Moving from Wilkes-Barre, Pennsylvania, to the Limestone Hill area, he started several businesses. Among them was a general store on a street he named Wilkesbarre Avenue. Later in 1910, Domowicz opened the Donowick Hotel at the corner of Ridge Road and the Hamburg Turnpike. (Courtesy of Romaine Lillis.)

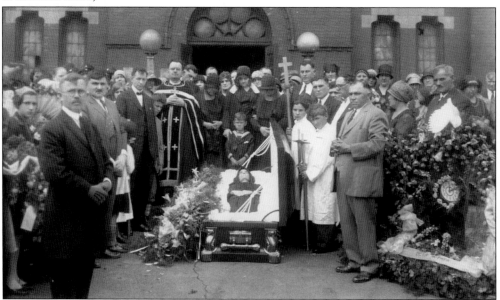

A common practice of immigrant groups in early Lackawanna was to photograph the deceased and send pictures back to family in the old country. This c. 1920 service shows a funeral at the St. Stephen Serbian Orthodox Church on Church Street in Lackawanna. The clock shows the time of death. (Courtesy of the Pawlak and Korach families.)

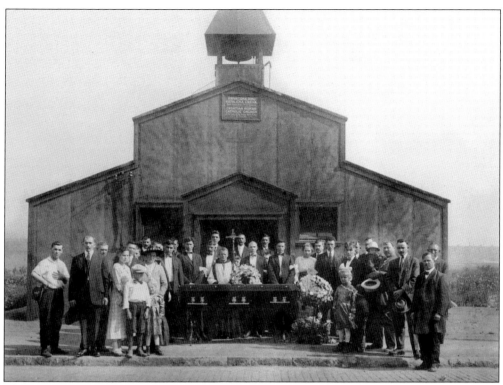

This is a funeral service held at the Croatian Roman Catholic Church of Our Lady of the Sacred Heart of Jesus with Rev. Leon Josip Medic, OFM, a Croatian Franciscan, presiding. The temporary structure, made of wood and tar paper, was dedicated on May 27, 1917, and was located at 109 Ridge Road near the steel plant. (Photograph by Karlo Petrinec, courtesy of Rev. Christopher Coric, OFM Conv.)

The second brick church of Our Lady of the Sacred Heart of Jesus, Croatian Parish of Lackawanna, New York, was dedicated on September 6, 1920, by the Most Reverend Bishop of Buffalo, H.E. William Turner. In 1919, Fr. Nelson Baker had blessed the cornerstone for the building as he had for the first wooden church. (Photograph by Karlo Petrinec, courtesy of Rev. Christopher Coric, OFM Conv.)

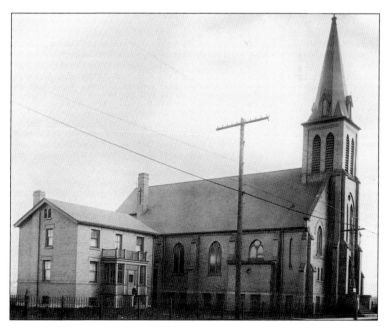

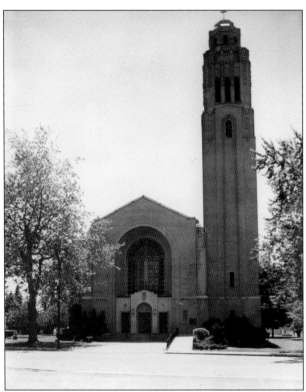

The birth of St. Barbara's Parish took place in the home of Adam Korejszy, where the first services were held. Father Marcinkiewicz, the first pastor, gave his initial sermon in front of the Stephen Kowalski home on Center Street. Rev. Franciszek Radziszewki is credited with building the exquisite edifice on the corner of Ridge Road and Center Street. (Photograph by Sterling Photography, courtesy of the Lackawanna Chamber of Commerce.)

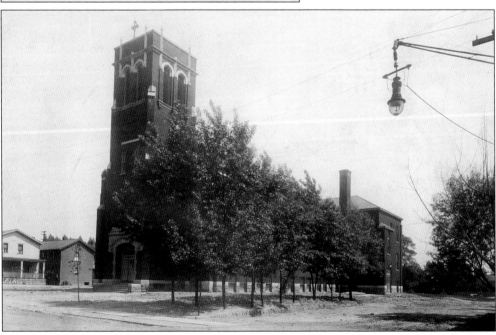

A further expansion of the Polish community required the construction of St. Michael the Archangel Church, with a ground-breaking ceremony in 1922. This church and parochial school, which survived the annual spring flooding of Smokes Creek, was destroyed by fire in the 1960s. (Courtesy of the Lackawanna Chamber of Commerce.)

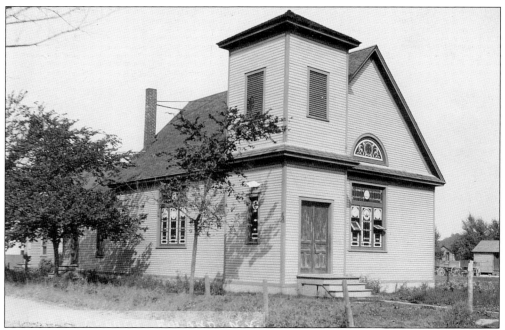

The new Roland Methodist Church congregation heard its first sermon by Rev. William Glaser on October 18, 1899. John McNeal opened his home on Roland Avenue for the first church services. He was assisted by a Mr. Torry and a Mrs. Richardson. This postcard shows the church as it originally looked, with its open bell tower and tall, pointed roof. The tower has since been modified. (Courtesy of the Lackawanna Chamber of Commerce.)

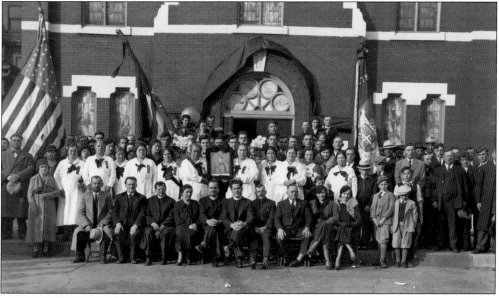

This picture was taken in October 1934 after a requiem at St. Stephen Serbian Orthodox Church in the memory of King Alexander I of Yugoslavia, who was assassinated in Marseilles, France. The church was the parish of the Lackawanna Serbian community on Church Street in the First Ward. Holding the picture of King Alexander are Ana Korach (left) and Milka Cagara. (Courtesy of the Steven Korach Memorial Church Library.)

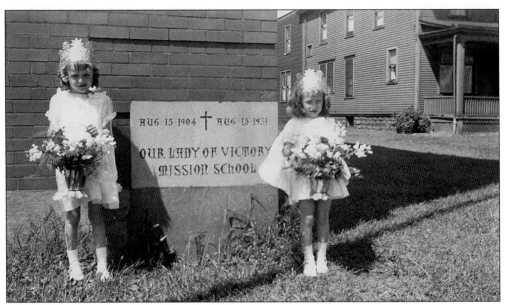

This picture depicts two girls who were "angels" at a Roman Catholic first communion ceremony at Queen of All Saints Church on Ridge Road in Lackawanna. They are standing near the cornerstone, which shows it was originally called Our Lady of Victory Mission School. Queen of All Saints had a school connected with the church. This church had a multiethnic congregation. (Courtesy of Linda Kovacs.)

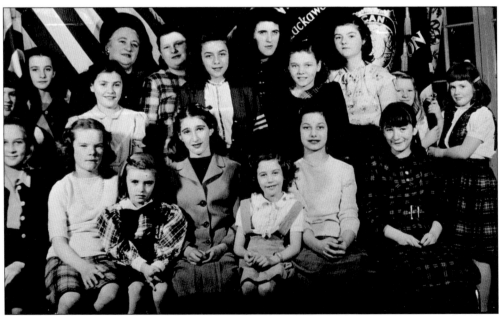

The Women's Auxiliary of American Legion Post No. 63 sponsored a junior auxiliary program for children of Lackawanna veterans. Henrietta Bodge was their guidance director. Auxiliary activities included Flag Day ceremonies for children with disabilities at the Franklin School. (Photograph by Charles D. Curtin, courtesy of American Legion Post No. 63.)

Six

THE ROOTS OF COMMERCE

One ripple effect of bringing the Lackawanna Steel Company to the shores of Lake Erie was the creation of a thriving business district in the city to meet the demands of new workers, residents, and other customers who were just passing through. But the businesses became more than just that. The restaurants and shops of the city became meeting places, beloved hangouts, and an essential part of the fabric that molds and holds a town together.

Some names are beloved by the people of this city like a second home—Curly's, Sterling Photography, Shea's Lackawanna, Rosinski Furniture, A.C. Hardware, and many others. In the peak production period of the steel plant, signs such as "Workingmen's Rest" or "Pay Checks Cashed Here" adorned the windows of many businesses, including the numerous watering holes that anchored nearly every block of the city. In the early 20th century, in fact, a person would be hard-pressed to walk a block in Lackawanna without passing either a church, a bar, or both. What this says about the city is not clear, except to say that Lackawanna small businesses will always hold a special place in the hearts of current residents and those long since gone.

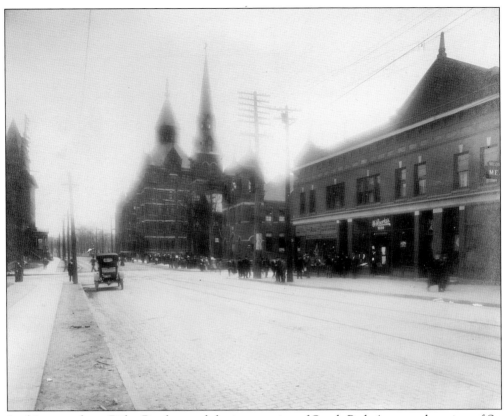

Looking east down Ridge Road toward the intersection of South Park Avenue, the spires of St. Patrick's Church and St. John's Protectory rise in the background. Following a fire in the church in April 1916, Father Baker initiated the construction of the basilica. The massive, four-story protectory for orphan boys provided 700 beds, six large school rooms, six dining halls, and extensive bathing and lavatory facilities. (Courtesy of the Widmer-Melohusky family.)

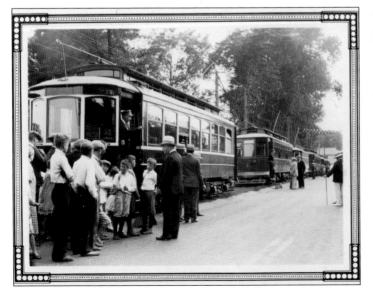

The first trolley lines reached the Limestone Hill area in 1897 with the completion of a line from South Park Avenue and Ridge Road to Blasdell, New York. Use of the street railways was the preferred mode of transportation for reaching the plant. The height of popularity for the trolley came in 1915. This was then replaced by public preference for bus routes in the late 1920s. (Courtesy of the Buffalo and Erie County Historical Society.)

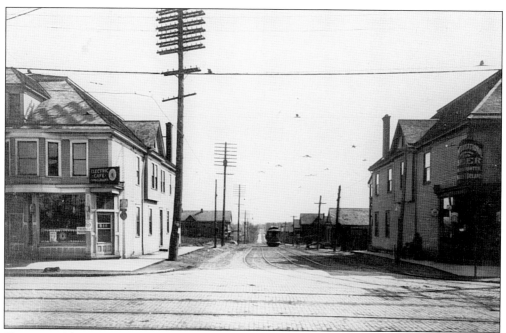

This view of the intersection of Ridge Road and Electric Avenue looks southward. The building on the left corner would become the future site of Curly's Grill. Electric Avenue became a major secondary north-south rail route extending to Blasdell, New York. (Courtesy of the Warthling family.)

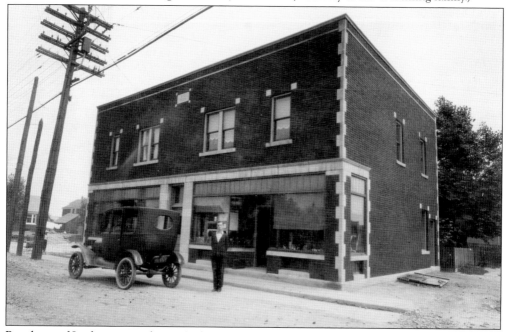

Residents of Lackawanna who were children in the 1920s recall businesses like A.C. Hardware Store on Electric Avenue as being the all-purpose store in their neighborhood. This business offered wallpaper, paint, hardware, and plumbing parts for making basic repairs. Since there were no trolley lines yet in this photograph, residents appreciated that this store was within walking distance of their homes. (Courtesy of the Lackawanna Chamber of Commerce.)

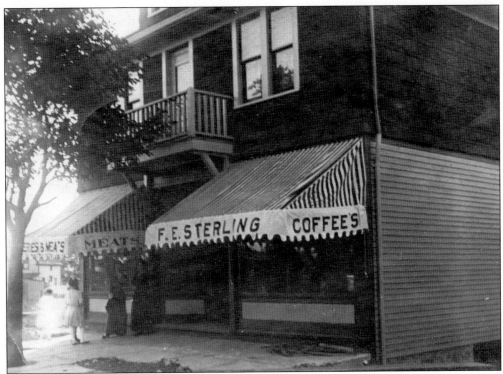

This grocery store was found in the Ridge Road Village (New Village) built on the Hamburg Turnpike. This second company housing project was designed differently than the Smokes Creek Village (Old Village) in order to surpass what commercial real estate companies offered in Buffalo. The nicer household conveniences were an attempt to appeal to the better-paid wage earners who did not want to deal with overbearing landlords. The grocery store was owned by Frank Sterling, who was born in Lackawanna. Local residents could obtain basic staples like meats, cheese, coffee, and vegetables within a close distance to where they worked. From this simple beginning, the Sterling family has had a business presence in the Lackawanna community to the present day. Richard Sterling has operated a photography studio on Ridge Road since the 1950s. (Both, courtesy of the Sterling family.)

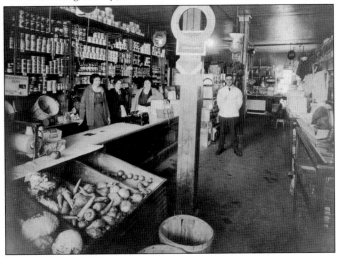

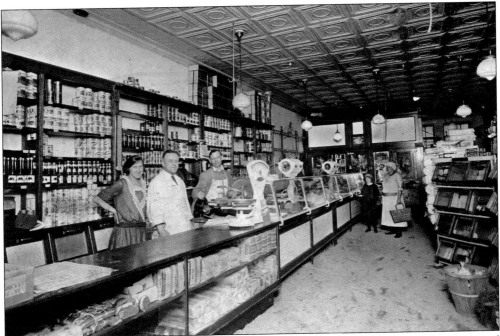

This interior photograph of Slifka's Market was taken on August 7, 1924. It was a family-owned and -operated business located on Ridge Road and Wasson Avenue in the First Ward. Behind the counter, from left to right, are Hattie Slifka (née Such), Henry Kaldajewski, and owner John Slifka. The customers are unidentified. Difficult financial conditions contributed to the closing of the market in the 1930s. (Courtesy of the Slifka family.)

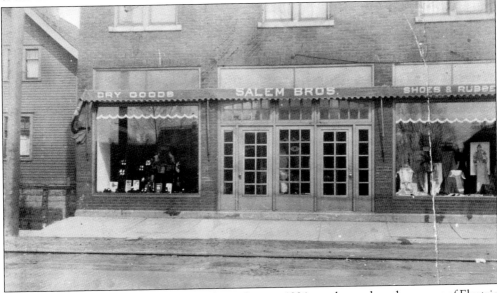

The Salem Brothers Department Store, shown here in 1924, was located on the corner of Electric Avenue and Warsaw Street. It was established by Carter Salem and his brother Joseph after their arrival from Lebanon in 1914. Salem served in the US Army during World War I and became an American citizen through his service. He also founded the Lebanese Club. (Courtesy of Edward Salem and the Salem family.)

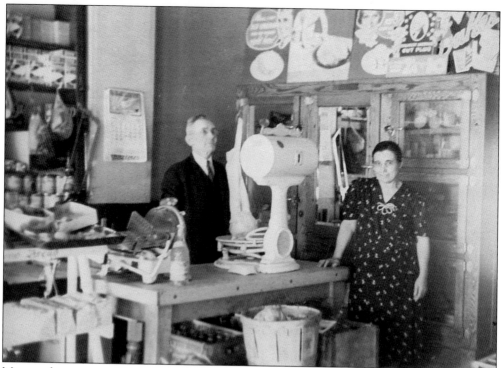

Mom-and-pop grocery stores provided residents with their daily foods and supplies. Janko and Ana Budimirovich were proprietors of this store at 83 Gates Avenue. Note the period essentials: scale, meat cutter, butcher-block table, and icebox. The Lackawanna Food Merchants Association had more than 50 member stores and vigorously protested the first proposed Erie County sales tax of one percent in 1947. (Courtesy of Nicholas D. Korach.)

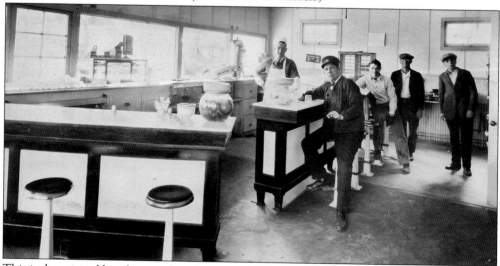

This is the original hot dog stand on the corner of South Park Avenue and Nason Parkway, built in 1923. Pictured are, from left to right, Donald L. Reed, manager; a Mr. Smith; Gusta Brady, city of Lackawanna chauffeur; Peter Micells, a painting contractor; and Thomas O'Connor, assistant manager/messenger. The stand was replaced by a brick building in 1927. (Courtesy of Linda Knight and the Reed family.)

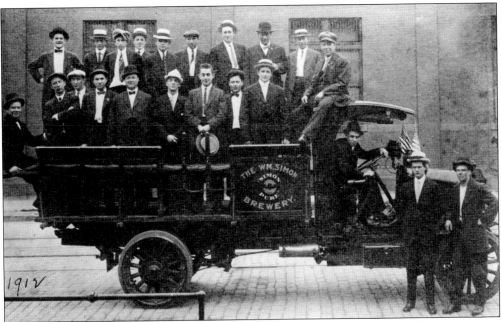

A survey that was done in October 1911 to describe the conditions of many steel plant communities included the new city of Lackawanna. The major breweries were located in Buffalo, but many bottling/distribution centers were located in surrounding areas. This truck is an example of an early model and shows the William Simon Brewery, which operated in Buffalo from 1854 to 1973. (Courtesy of the Lackawanna Chamber of Commerce.)

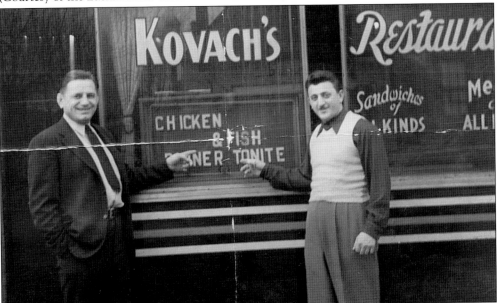

Elek and Mary Kovach, emigrants from Hungary, ran their restaurant at 45 Wilkesbarre Avenue, in the shadow of the steel mills, until 1951. It was a favorite gathering place for the workers of the plant to enjoy sharing a drink, stories, and a meal. The family name is now Kovacs, with a change of name common to many immigrants. Shown here are two unidentified regulars from the neighborhood. (Courtesy of Linda Kovacs.)

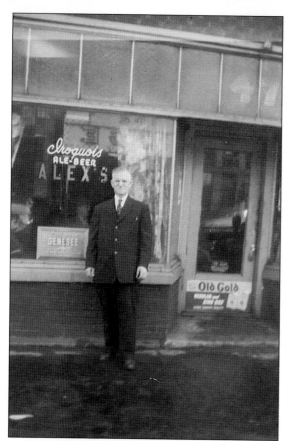

Alex Eftimio and family operated and lived above Alex's Grill at 47 Ridge Road. They also provided boarding for steelworkers. Fridays were busy when steel and dockworkers would flood Ridge Road establishments. They would cash their checks and bring families out for a fish fry. On one block alone, there were six taverns and three restaurants run by Moroccan, German, Croatian, Macedonian, Syrian, and Spanish families. (Courtesy of Vera Hughes.)

Here is a typical night at Alex's Grill in Lackawanna. Customers would come to enjoy glasses of cold beer for 10¢ and a fish fry for 15¢. During the holiday season, taverns had all-night licenses on New Year's Eve, and three of Alex's six daughters worked those hours. During those years, Lackawanna had beat police, who were always a presence in the businesses. (Courtesy of Vera Hughes.)

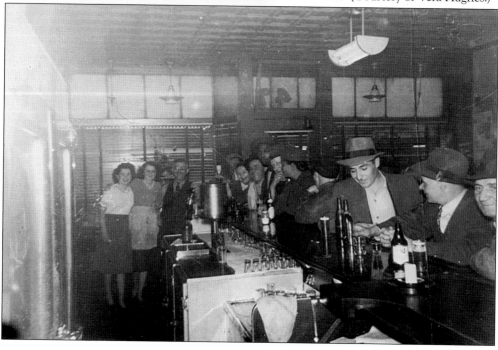

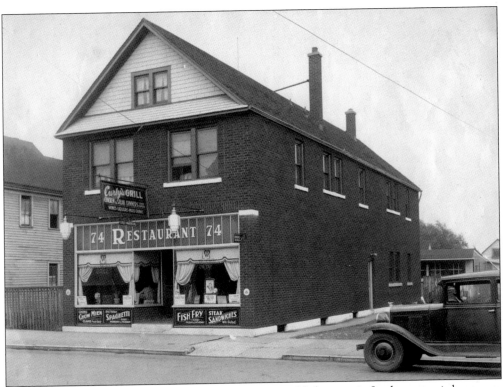

One of the longest-operating tavern and restaurant establishments in Lackawanna is known as Curly's Grill. It was founded by Francis Warthling. This photograph shows its first location at 74 Gates Avenue in the city's First Ward from 1934 to 1938. Above the tavern lived the building's owners, Dmitar and Ana Korach, and their children. In the rear, steelworker families resided in the two back apartments. (Courtesy of Nicholas D. Korach.)

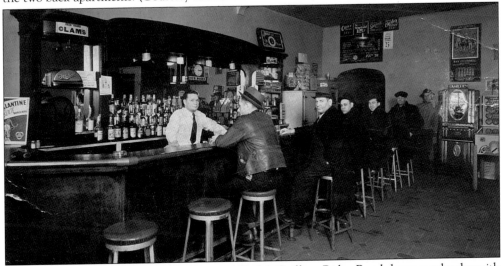

This interior view of the second location of Curly's Grill on Ridge Road shows a calendar with the date April 1941. The tavern was open seven days a week, and the menu on the far wall lists some of its reasonable selections. Behind the bar is Carlton Reed, son of Asa Reed, one of the prominent early citizens of Lackawanna. (Courtesy of the Reed family.)

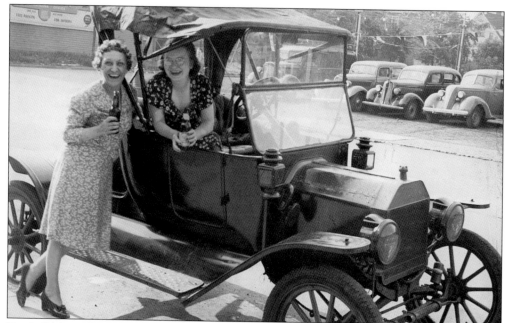

Two ladies have fun in a vintage car outside of Curly's Grill in the 1940s. Automobiles were becoming more of a feature in this community. Business owners needed cars for obtaining supplies, but they were still out of reach for many families. One resident recalled that automobiles like the Ford Model T did not have heaters, so large blankets were needed for winter travel. (Courtesy of the Warthling family.)

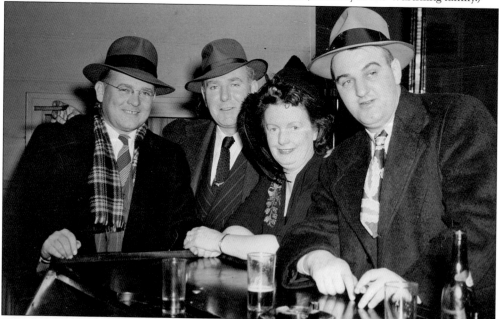

This photograph was taken at Curly's Grill in 1940 following Sunday mass at Our Lady of Victory Basilica. It captures the spirit of Curly's in a reflection of the diverse culture and the importance of restaurant taverns in Lackawanna. In the photograph, from left to right, are Bud Couhig, assistant principal of Lackawanna High School; Joe O'Conner, from the Hotel Lackawanna; Mae Warthling, co-owner of Curly's Grill; and Mannis Langon, a steelworker. (Courtesy of the Warthling family.)

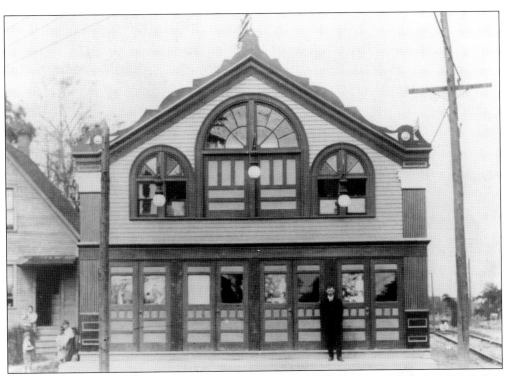

Nickelodeons, or moving picture theaters, opened in small storefronts wherever ambitious entrepreneurs could be found. These were many immigrants' first business venture. Featured here is the A.C. Theater on Kirby and Electric Avenues in Lackawanna. It was the first one in the city and was owned by Anthony Cosnyka, who is standing in front of it in July 1912. (Courtesy of the Buffalo and Erie County Historical Society.)

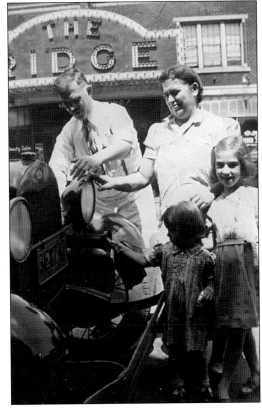

Across the street from Alex's Grill was the Ridge Theater. It was the only theater in the First Ward until the Shea's Lackawanna opened in the mid-1940s. Admission for children was 10¢ and adults cost 25¢. Alex Eftimio and his wife, Kosta, with daughters Lilian and Irene, admire the family's Ford Model T outside of their business. (Courtesy of Vera Hughes.)

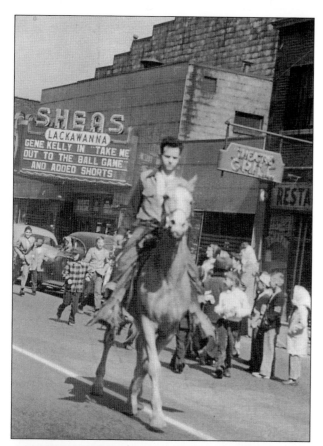

Children, dressed for cooler weather, stand in front of Shea's Lackawanna Theater on Ridge Road as a holiday parade passes by. The year is likely 1949, because the movie *Take Me Out to the Ballgame*, as seen on the marquee, was released that year. The rider is young John Mendolia on his horse Pal. Shea's was the second movie theater that opened in the 1940s in Lackawanna. (Courtesy of Romaine Lillis.)

In the demand for expansion of the business district, moving a house this large had to be quite an ordeal back in the 1940s. It is remarkable that even the front and back porches were still intact. The house was owned by a Mrs. Murphy and was moved from South Park Avenue around the corner to Parkview Avenue. A local company that wanted to expand its dealership prompted the relocation. (Courtesy of Rita Tarquino.)

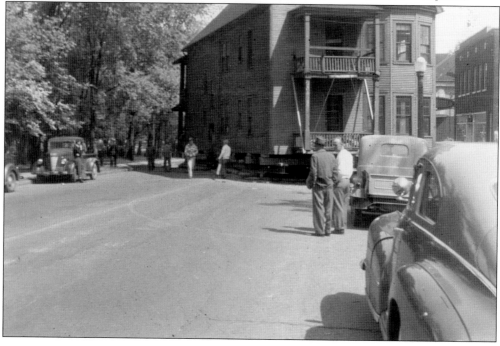

Seven

SOCIAL AND CIVIC INTERESTS

Some of the most precious memories in life are during times of recreation. Baseball games have, for a long time, been a part of Americana. Due to the presence of the Lackawanna Steel Company, the city attracted a variety of ethnic groups who flocked to baseball games. This purely American sport was a way for people to show their patriotism by attending and playing games. Many immigrant workers in the early 20th century suffered from discrimination and dehumanizing work. In baseball, they found a sport that was inherently fair, democratic, and emphasized the individual—things not typically found in many peoples' lives.

The game of American football was also going through a transition period in the early 20th century from a rugby-like sport to one that included significantly different rules. With this, the popularity of the sport exploded on the academic level. It could be played once a week on the weekend, which was perfect for busy students on the high school or college level, such as the championship teams of Lackawanna High School in the 1930s.

With so many businesses and churches, the warm summer months never seemed to go by without weekends packed with company outings, like Bethlehem Steel events, a Knights of Columbus carnival, a church theatrical production, family parties, or stirring recitals by local singing groups. Such variety bespeaks the diversity of this blossoming city and the need to enjoy things due to the sometimes exhausting nature of immigrant life.

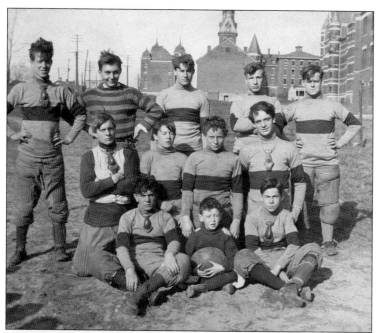

Young boys pose while playing on the grounds of Father Baker's Houses of Charity in the early 1900s. The rear of St. Patrick's Church can be seen in the distance. They boys are, from left to right, (first row) Joe Quinn, Joe Shea, and Jack Joynt; (second row) Glen Bedford, Danny Shea, Cohnell McGill, and Jack Joyce; (third row) Ed Joyce, Adolph Jentz, Will Shea, Frank Kapinos, and Walter Gannon. (Courtesy of Dr. Edward Gannon.)

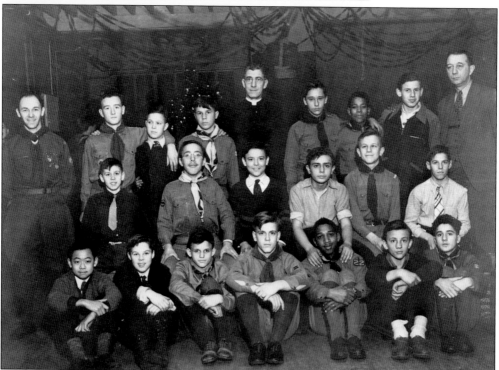

The Lackawanna Council of the Boy Scouts of America was a large organization. Its influence included troops from areas south of the city such as Blasdell, Big Tree, and Windom. These Scouts are part of the troop affiliated with Our Lady of Victory. Bob Avery, who owned a hardware store and floral shops on Ridge Road, was an active supporter of Scouting. The priest is unidentified. (Courtesy of Harold Blattenberger.)

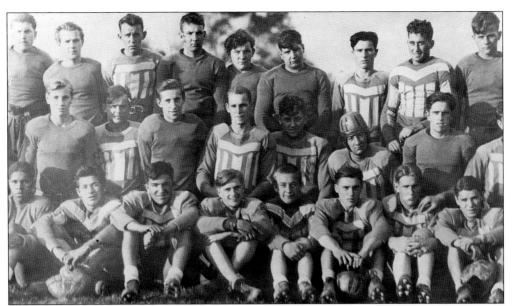

Lackawanna High School football coach Delzon "Del" Fisher developed great championship teams in the early 1930s. He opened the avenue for college scholarships for his players. During these Great Depression years, college tuition was prohibitive. Standout players of this era who turned their athletic prowess into college diplomas included Jim Downey, Steve Korach, Joe Amorosi, Frank Rustich, John Devic, John Pancyzkowski, Mike Maricich, John Novak, and others. (Courtesy of Nicholas D. Korach.)

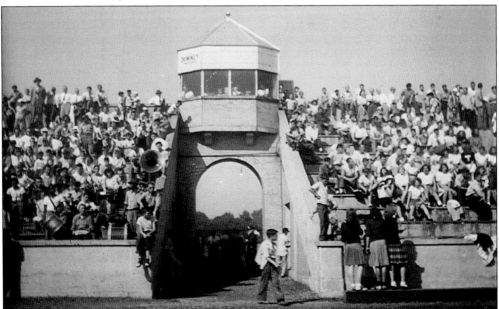

The place for high school students to be on a Saturday afternoon was, of course, the stadium. They came to encourage their football team as the cheerleaders led the cheers and the singing of the school song. By the looks of the filled stands, it seems as though most of the students attended the games. The old enclosed announcer's studio above the arch is no longer there. (Courtesy of Mary Pawenski.)

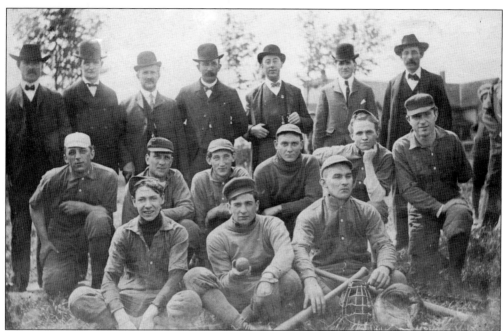

As America's homegrown game, baseball was an important activity for residents of Lackawanna. Many local business owners and politicians, like John Widmer and his colleagues (in the third row), sponsored teams in West Seneca and early Lackawanna. Even returning soldiers who had temporary housing at Old Lady of Victory played baseball to pass the time while they sought employment. (Courtesy of the Widmer-Melohusky family.)

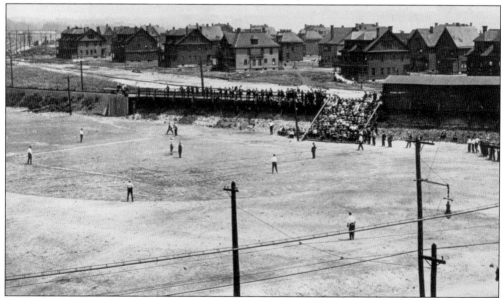

An aerial view shows a baseball game being played near the Ridge Road Village (New Village). This baseball diamond, on property owned by Lackawanna Steel, was adapted from a railway stop along the tracks. The shed is part of a South Buffalo Railway stop used by workers from Buffalo. The grandstand is actually a stairway from the ground level for passengers. (Courtesy of the Steel Plant Museum of Western New York.)

Lackawannans have always loved carnivals, especially when television and other electronics were not available. A carnival was where friends met for an evening of fun. This 1947 Dealing's Rides carnival was on Dona Street and was visited by (from left to right) Stanley Krasinski, Mary Alex (Fiore), Mary Anne Bukaty (Moretti), Honey Krasinski (Moretti), and Nick Welchoff. (Courtesy of Mary Pawenski.)

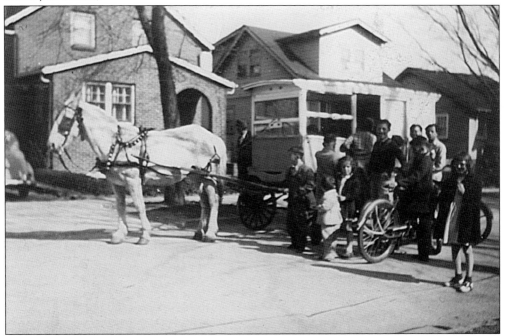

"I scream, you scream, we all scream for ice cream!" From the youngest child to older teenagers, all were crowded around the horse-driven ice cream wagon to get a taste of the universally loved treat. The scene takes place in Bethlehem Park in the 1940s. (Courtesy of Mary Pawenski.)

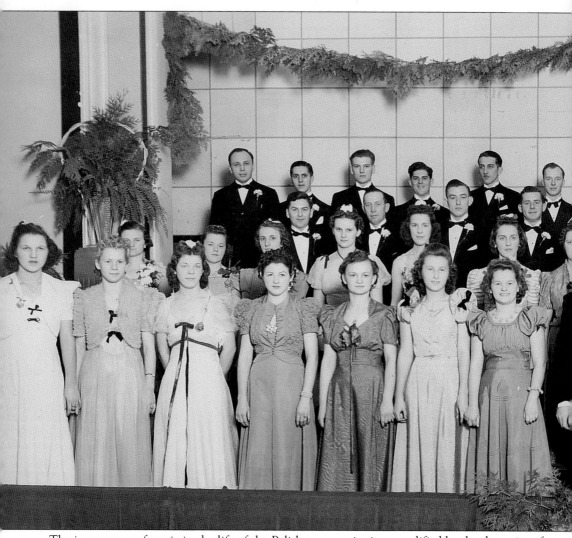

The importance of music in the life of the Polish community is exemplified by the sheer size of this choir. This was the concert choir from the parish of St. Barbara's Church. This event was held

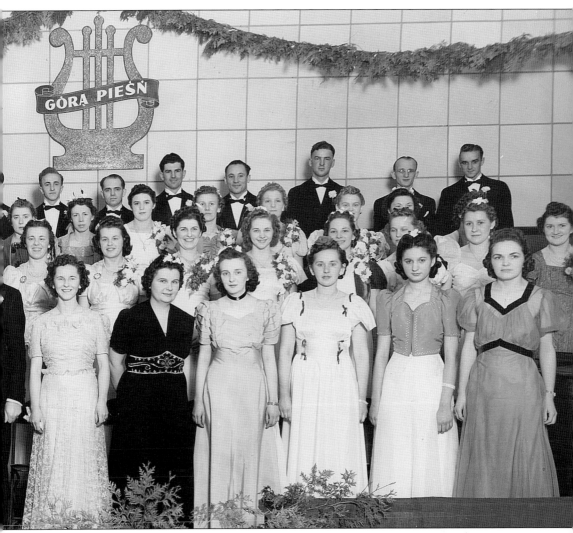

on November 26, 1939. Musical and theatrical productions were a major community happening. (Courtesy of Daniel Kij.)

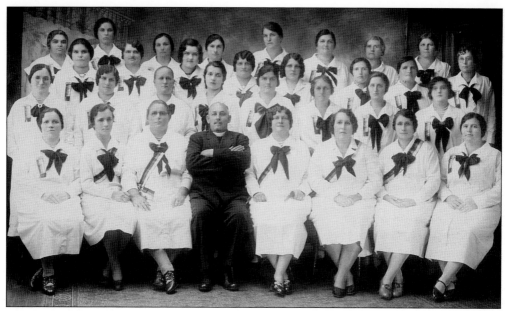

The Roaring Twenties would change the role of women in America forever. This photograph shows the women's organization St. Ilija Circle of Serbian Sisters. It was founded in Lackawanna in 1928 to support a local church. First president Ana Korach is pictured to the left of the congregation's priest, Rev. Djordje Petrovitch, along with 30 "sisters." (Courtesy of Nicholas D. Korach.)

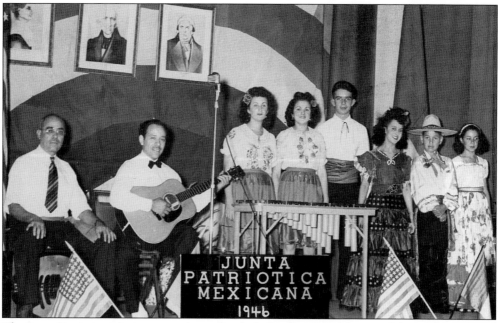

The Junta Patriotica Mexicana was created to help families from Mexico celebrate their culture. Mexican workers filled jobs at the plant during the manpower shortage that occurred during the war. In 1947, the Central Social Club Mexicano was organized and opened its own building. Playing traditional music at an event in 1946 are (from left to right) Eusebio Orozco, Ralph L. Calderon, Louise (Orozco) Kosanovich, and Josephine Orozco. (Photograph by Norman McNamara, courtesy of Laura Kosanovich.)

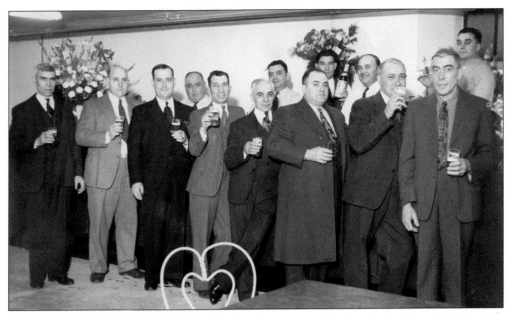

In 1919, Marcos Gomez emigrated from Spain to America, and he later helped found the Spanish Welfare Association. The group purchased a building on Ridge Road for it meetings and events in 1924. The site was the former Liberty Theater, which was owned by the Moses family. This photograph shows some of the association's members at an event in the 1940s. (Courtesy of Mel and Marguerite Pawlak.)

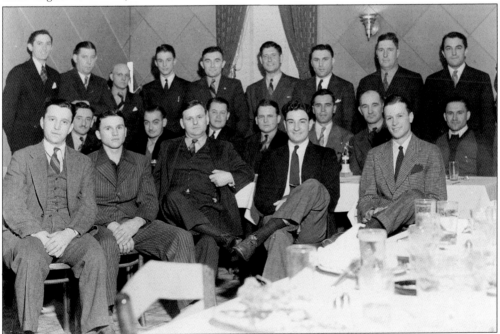

Before the advent of television and multimedia, social, civic, and theatrical clubs flourished in the city. The Gates Athletic Club Bowling League held its first annual banquet at Rooth's Iron Gates Tavern on May 15, 1940. Steven Korach, an outstanding local athlete and educator, is standing third from right in the third row. (Courtesy of Nicholas D. Korach.)

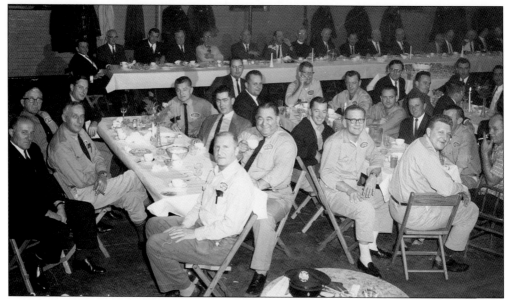

Even before the formal establishment of the city, civic-minded citizens organized to deal with the hazards of fire. To complement this in 1921, the Lackawanna Fire Department Benevolent Association was formed to promote fellowship among its members and provide financial assistance to those in need. Firefighters are shown at a communion breakfast at Fire House No. 1 on Ridge Road in the 1940s. (Courtesy of William Tojek.)

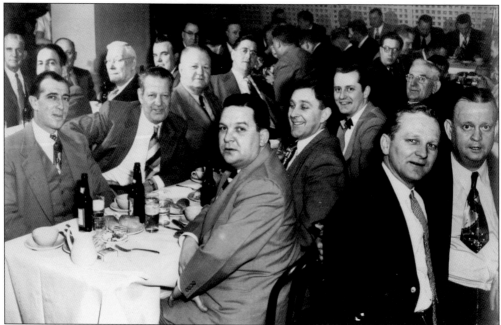

The Limestone Hill Club was organized at the Limestone Grill on Ridge Road near the Hotel Lackawanna. It supported needy causes such as events for handicapped children who attended the Franklin School. Annual dues helped sponsor banquets to honor outstanding athletes from Lackawanna High School. Featured from left to right, beginning at the far left of the front table, are Bill Rafter, Francis "Curly" Warthling, Bill Sweeney, and Bill Gallagher. (Courtesy of the Warthling family.)

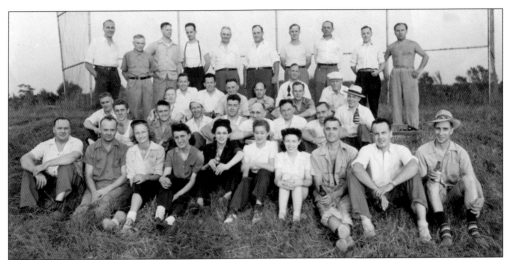

Bethlehem Steel Corporation's engineering departments held this outing at Chestnut Ridge Park in Orchard Park, New York, on July 6, 1944. During World War II, women began to be employed in large numbers. Notice the women in the front row and that the men are middle-aged (thus draft-deferred). (Courtesy of Nicholas D. Korach.)

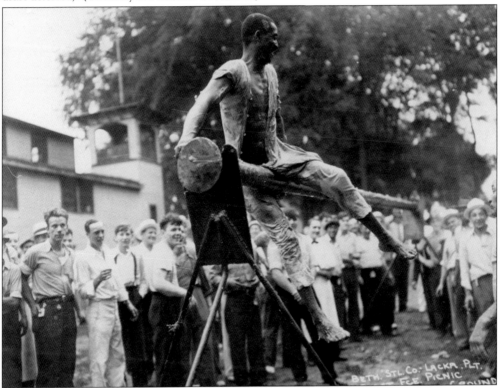

In the 1920s, redesign and reconstruction of the blast furnaces began, and it carried through into the 1940s. Anticipation of greater demands of pig iron due to World War II was the deciding factor. The result was that the combined production of old and new furnaces set new records. In this photograph, the workers enjoy some recreation at a blast furnace picnic held on August 7, 1937. (Courtesy of the Steel Plant Museum of Western New York.)

The different departments and production areas of Bethlehem Steel's Lackawanna plant celebrated holidays with outings and picnics. Signs of the holiday season could be seen on administration and worker buildings throughout the plant. This Christmas Chorus performed at an annual Christmas party on December 21, 1948. (Courtesy of Mel Pawlak.)

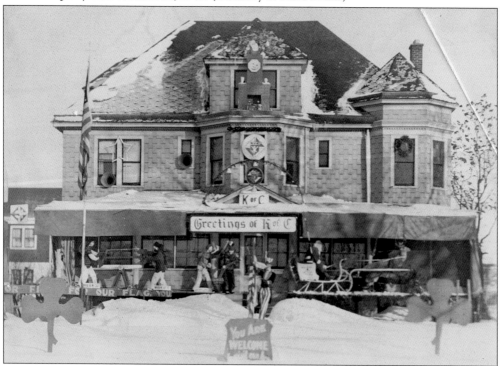

This was the second location of the Knights of Columbus No. 2243, once located on Rosary Avenue. The organization held carnivals on the front lawn yearly and also decorated the house for the Christmas holiday. The lights, figures, and music from the loud speakers were a delight. Unfortunately, a short circuit in the Christmas lights started a fire that burned down the building in December 1954. (Courtesy of the Knights of Columbus.)

Eight

CENTERS OF LEARNING

For some of the immigrants, jobs at the steel plant were a sufficient future for their children. However, one of the most important goals of many immigrants and pioneers was to see the next generation educated. Learning to read and write was an obtainable goal, and for those who could afford it, a college education was possible. It was a desire rewarded by many of the second generation becoming professionals in education, law, and business. Two schools for pioneer youngsters were built by the town of West Seneca before the turn of the century. As the arrival of new residents increased, the additions and expansions of schools were built to accommodate the flood of new students. The foresight of the board of trustees under the leadership of chairman John Widmer, along with the hard work of dedicated teachers, led to quality academics as well as quality physical facilities.

Evolving from ethnic singing societies and crafts from the many different cultures, the arts, such as chorus, band, and drawing, were added to enhance school curriculum. Physical fitness and sports teams were introduced to round out students' education. Later, vocational classes, such as homemaking and woodworking, were initiated.

By the extraordinary efforts of Clara Whealen and the Pioneer Study Club, a new library was added to augment the learning process at school. It was only after much persuasion of the Carnegie Corporation, the public, and state and city governments that a library was built. Many obstacles had to be overcome before the first shovel of dirt was overturned to start construction. It was necessary, with permission of New York State, to acquire land that constituted an unkempt cemetery for the indigent from the City of Buffalo. With the Carnegie Corporation delaying its support for the library and the start of World War I, the necessity to convince the city to contribute funds for the library became imperative. Nevertheless, the steadfast work of Whealen and the Pioneer Study Club resulted in the opening of the Lackawanna Public Library on July 10, 1922.

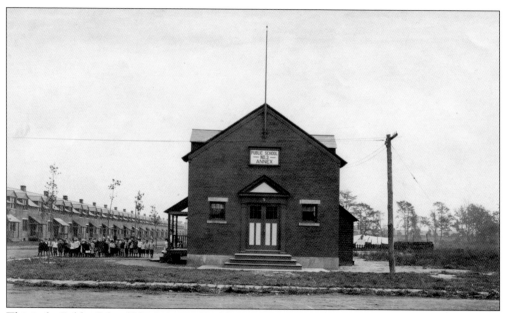

This is the Public School No. 3 Annex Building in front of the Old Village Housing Complex. This brick structure was built to accommodate 500 pupils and was located about half a mile from Ridge Road. By 1907, this was one of four new schools needed to serve the increasing population of families attracted by employment at the steel plant. (Courtesy of the Widmer-Melohusky family.)

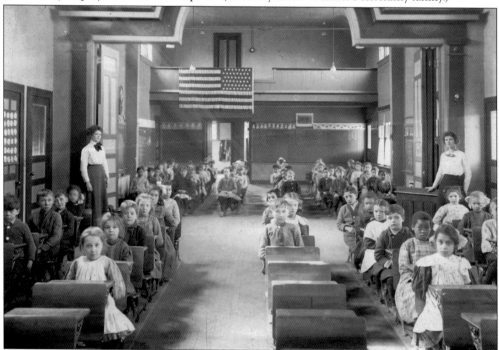

This photograph shows a kindergarten class at the Smokes Creek Village Public School No. 3 Annex. These children reflect the many nationalities that came to work in the steel industry. Among them are various Native Americans, Irish, Polish, Croatians, Russians, Czechs, Hungarians, Greeks, Syrians, Spanish, Bulgarians, and Serbians. (Courtesy of the Widmer-Melohusky family.)

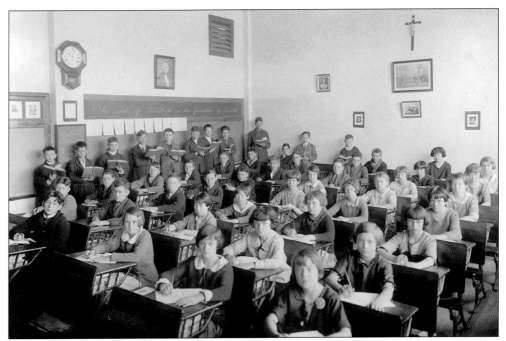

This classroom photograph was taken in an unidentified Catholic school, possibly at either St. Barbara's or St. Hyacinth's Church. The time on the clock indicates a few minutes past 10 a.m. The small blackboard under the clock has "Excellence" and "October 1924" written on it in cursive. The inscription across the long blackboard reads, "The end of education is the foundation of character." (Courtesy of the Widmer-Melohusky family.)

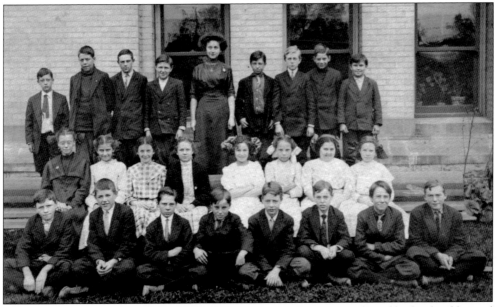

School No. 1 was an old frame building that became a combination grade and high school located on Ridge Road. The unique feature of this seventh-grade class photograph is that it was processed as a postcard. A young Mae Keefe is seated amongst her classmates in the second row, third seat from the left. (Courtesy of the Warthling family.)

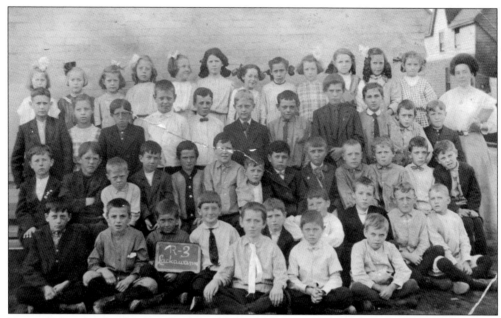

Pictured above is the third-grade class of School No. 1 in 1910. It was part of the Lackawanna School District and located in what was known as the Old Village. Some of the students in the picture are Tom Clark, Tom Castin, Ryan Miller, Bob Ormsby, Dennis Regan, Walter Widmer, Eddie Ormsby, Bill Carey, Whitie Bates, Leo Leary, Mary Pottiger, Agnes Stapleton, and Alice Aldrich. (Courtesy of the Widmer-Melohusky family.)

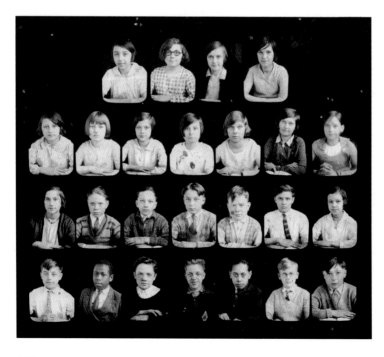

This is a sixth-grade class of the Wilson School in 1929. This school was built in 1903 and was almost across the street from the Bethlehem Steel plant. These are the faces of the sons and daughters of immigrant steelworkers. The photographic technique combining individual portraits into a group image is unusual. (Courtesy of Nicholas D. Korach.)

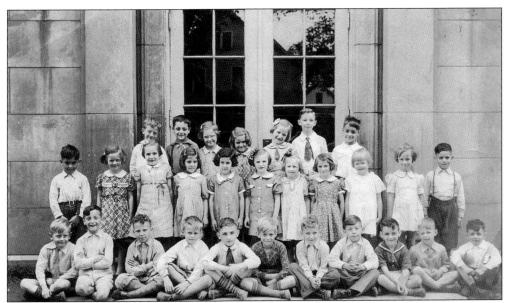

The major elementary schools within the Lackawanna School District in the early years were named after US presidents. This is the 1937–1938 first-grade class of M. Shea at the Washington School on Johnson Street. Bob Wall is in the first row, fifth from the right. (Photograph by A. Chripka; courtesy of Bob Wall.)

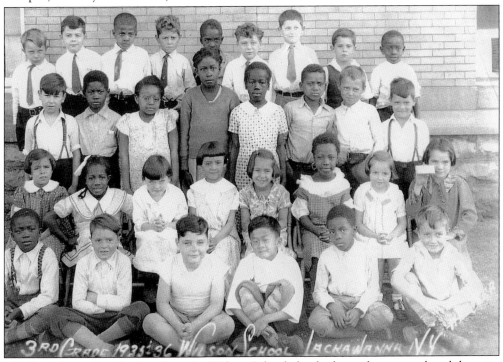

Mrs. Breen's third-grade class from the Wilson School clearly shows the great cultural diversity within the school during the 1935–1936 academic year. Paul Warthling is standing in the back row, second from left. Unfortunately, the subject of the card that the young girl is holding remains a mystery. (Courtesy of the Warthling family.)

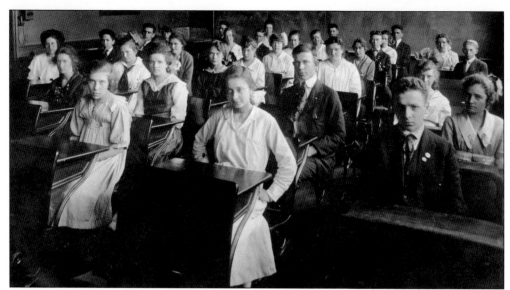

This photograph shows the senior study hall at Lackawanna High School No. 1 in 1916 or 1917. Students identified include Mary Cusick, Agatha Smith, Nora McLaughlin, Edward Joseph, Irene Kambat, Elsie Peterson, Esther Reed, Dorothy Highland, Joe Shea, Mary Pottiger, Walter Widmer, Mary Daley, Raymond Sheffield, Kathryn Mescall, Julia Stawsky, Joe Mescall, Margaret Shea, and Alice Aldrich. (Courtesy of the Widmer-Melohusky family.)

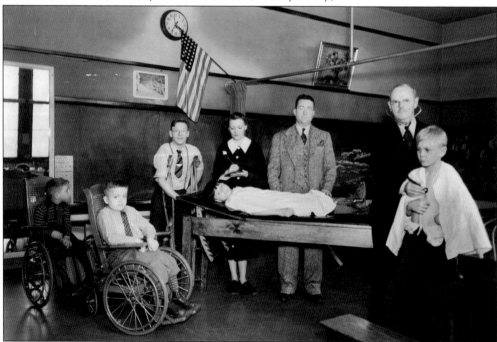

Many children were affected by the flu and polio epidemics that occurred after 1916. A school for children with disabilities was established at the Franklin School in September 1936. The program was supervised by Katherine Baldwin along with instructors Mary McCarthy and Anna Smerka. The doctor, staff, and children in this photograph are unidentified. (Courtesy of Lackawanna City School District.)

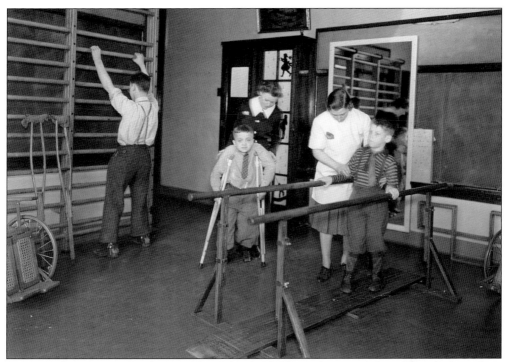

Here is a therapy room at the Franklin School. Children who were left with residual paralysis following an illness or an accident received therapy along with braces, crutches, and wheelchairs. These treatments were required to combat the muscle atrophy due to limited limb usage. The children and staff are unidentified. (Courtesy of Lackawanna City School District.)

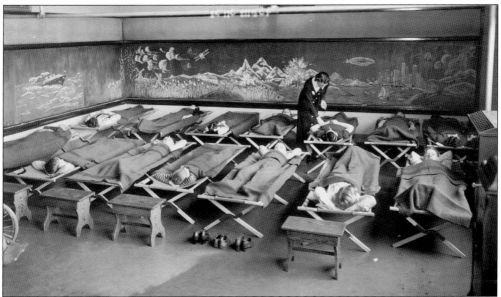

An elaborate hand-drawn mural on the chalkboard enhances this classroom for children at rest. Some early treatment methods for paralysis emphasized rest along with immobilization to reduce shortening of muscles. Later, treatments like the Kenny method used hot, moist packs on weakened tissue and exercise for unaffected muscles. (Courtesy of Lackawanna City School District.)

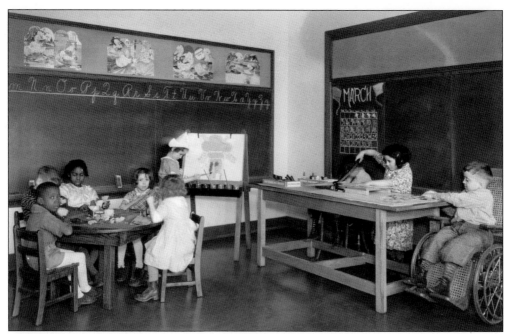

Children are engaged in art activities on Monday, March 20, (year unknown) at the Franklin School, which opened in 1925. This specialized program continued to expand so that by 1959 there were 64 students who were taught by five instructors. A designated school such as this was unique for a system in a city of Lackawanna's size. (Courtesy of Lackawanna City School District.)

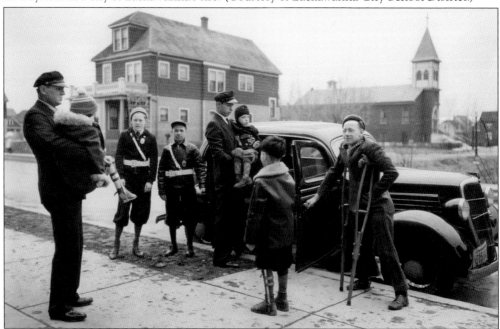

A special taxi and professional drivers pick up students with disabilities at the Franklin School. This shows the district's efforts to meet these children's needs before the advent of adapted buses. In the background is the Holy Trinity Polish National Catholic Church. Its cornerstone was blessed in 1930. (Courtesy of Lackawanna City School District.)

These children are outside in the play yard of the Friendship House Nursery School on Wilkesbarre Avenue. Equivalent to a modern-day preschool, the nursery school, including lunch, was sponsored by the Presbyterian Church. Pictured at far left is Romaine Torba, playing in the sandbox, and next to her, the boy dressed in the hat, sweater, and argyle socks is her brother Edward "Bud" Torba. (Courtesy of Romaine Lillis.)

This old wooden bridge crosses over Smokes Creek from Bethlehem Park to the site of the now-demolished Old Village houses built by Lackawanna Steel Company for its workers. It later functioned as part of the pathway for students from Bethlehem Park on their way to school at the Lincoln Annex. (Courtesy of Mary Pawenski.)

In 1923, Bethlehem Steel management purchased 60 acres of land on the east side of the Hamburg Turnpike. A small community of residential houses was developed that included paved streets, landscaping, and playgrounds. This 1939 photograph shows the Bethlehem Park School, which served the children of the area. (Courtesy of Harold Blattenberger.)

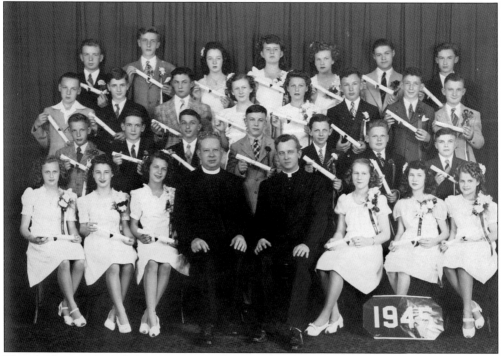

The children of the Polish community, who attended the parochial school of St. Michael the Archangel Church, received instruction from the Felician sisters. This graduation class is from St. Michael's in 1945. Bob Wall is second from right in the third row. (Courtesy of Bob Wall.)

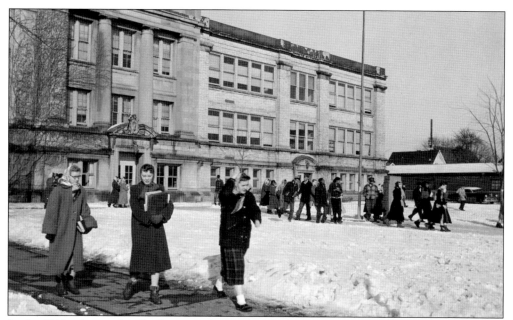

In the 1940s, the youth of Lackawanna began their high school education at the Franklin Annex or the Lincoln Annex in the First Ward. However, all would come together as seniors at the Lackawanna High School. In this winter picture, all of the young women are wearing scarves, as was the fashion of the day. (Courtesy of Romaine Lillis.)

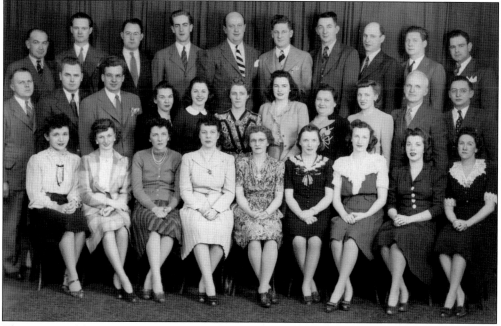

The passage of the Selective Training and Service Act of 1940, the first conscription in peacetime, had a noticeable impact on the Lackawanna schools. With the eligibility directly on the male faculty, the number of women teachers increased dramatically, as seen in this photograph of the Lincoln Annex faculty in 1943. Mary M. Korach (first row, far left) received her teaching assignment during this difficult time. (Courtesy of Nicholas D. Korach.)

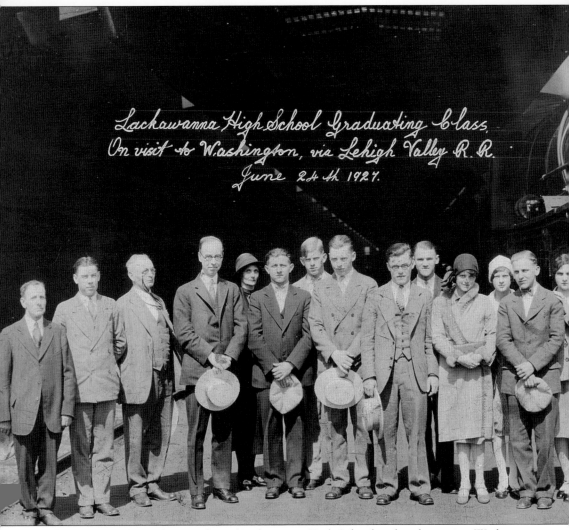

Lackawanna High School Graduating Class,
On visit to Washington, via Lehigh Valley R. R.
June 24th 1927.

The seniors in the graduating class of Lackawanna High School took a class trip to Washington, DC, on June 24, 1927. The group travelled via the Lehigh Valley Railroad. It is known that they visited Mount Vernon, Virginia, on June 27, 1927. Class officers included Stanley Kozera,

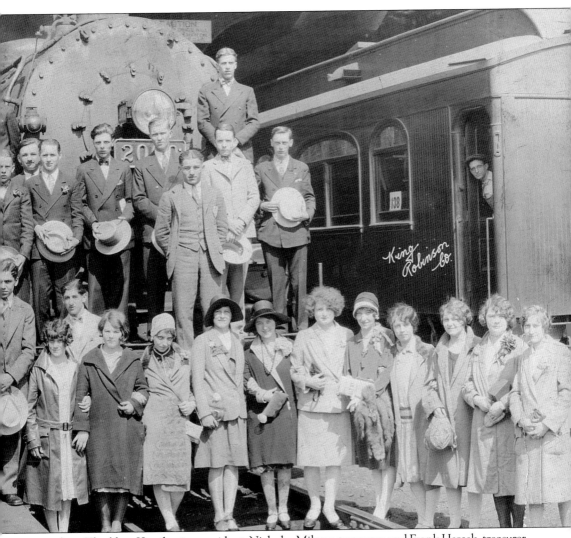

president; Thaddeus Kuwik, vice president; Nicholas Milano, treasurer; and Frank Hercek, treasurer. (Photograph by King Robinson Company, courtesy of Lackawanna City School District.)

Clara Whealen was the dynamic force behind the acquisition of a library for the city of Lackawanna. She wrote letters to the Carnegie Corporation and to anyone else she thought might help her cause. Whealen also wrote many articles for the local newspaper to convince the public a library was a necessity. The Carnegie Corporation finally answered her request. (Courtesy of the Lackawanna Historical Association.)

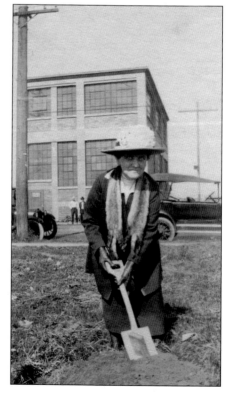

Clara Whealen is featured here in the ground-breaking ceremony for the construction of the library in 1921. The shovel was hand-carved by Thomas Collins and is inlaid with a decoration of a book and the year 1921. It is still on display in the library museum. (Courtesy of the Lackawanna Historical Association.)

This photograph shows the fireplace in the children's room being built. The room is located in the basement of the library. Unfortunately, there are no photographs of the completed fireplace, and it has since been removed. (Courtesy of the Lackawanna Historical Association.)

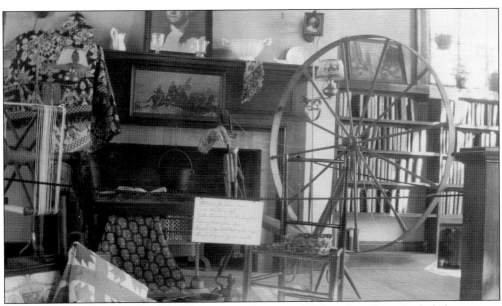

On display in the early days of the library is a collection of Colonial artifacts. Included are a yarn winder, a quilt, ironstone ware on the fireplace mantel, an iron kettle, and a lovely woven coverlet with an eagle border. The centerpiece of the picture is a beautiful spinning wheel that has held a place of honor since the library opened. (Courtesy of the Lackawanna Historical Association.)

This photograph is of the children's room and features a doll displayed in a child-sized chair. The items pictured are on a small platform. It was used as a stage where children were able to perform plays. This cozy scene no longer exists, but it brings back many memories to those old enough to remember it. (Courtesy of the Lackawanna Historical Association.)

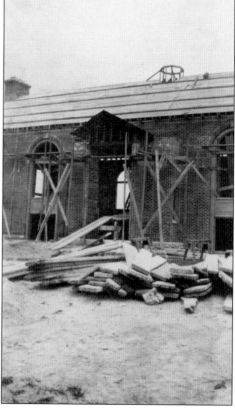

Framing the structure for the library building is well underway in this photograph. Pictured is the skeleton of what will become the completed front view. The windows are arched, and the wide opening in the center housed double doors. Very few changes have been made to the original construction. (Courtesy of the Lackawanna Historical Association.)

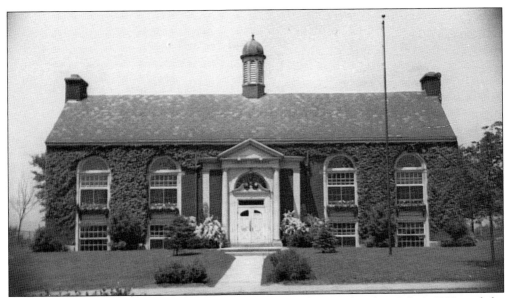

Construction of the Lackawanna Public Library was finally completed on July 1, 1922, and the facility was dedicated on July 10, 1922. This postcard shows the facade of the graceful Federal-style building with its lovely arched windows and large white columns adjacent to the double front doors. It fulfilled the dreams of a grateful city. (Courtesy of the Lackawanna Historical Association.)

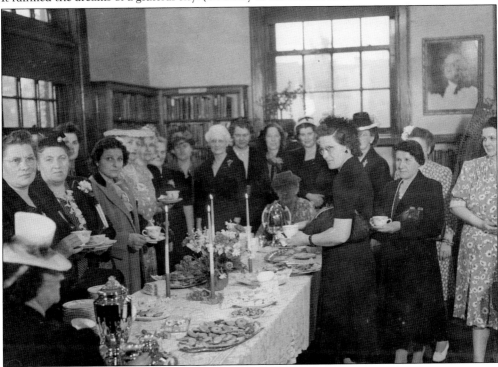

Pictured is the 25th anniversary celebration of the dedication of the library in July 1947. Clara Whealen, age 72, was present. She died at age 83. The beautiful lace-covered table set with flowers, candles, and silver tea servers and piled with cookies and tea was no doubt the scene of after-meeting refreshments. (Courtesy of Lackawanna Public Library.)

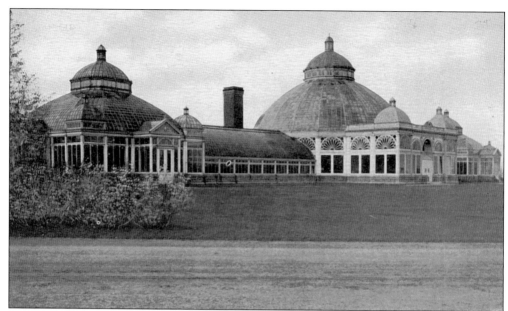

Buffalo and Erie County Botanical Gardens opened in 1900 as a gateway to South Park designed by Frederick Law Olmsted. The three-domed structure housing exotic plants was designed by Lord and Burnham. It was the third largest public greenhouse in the United States when it opened. Today, the garden is one of two remaining Lord and Burnham conservatories incorporated into an Olmsted-designed park. (Courtesy of the Lackawanna Chamber of Commerce.)

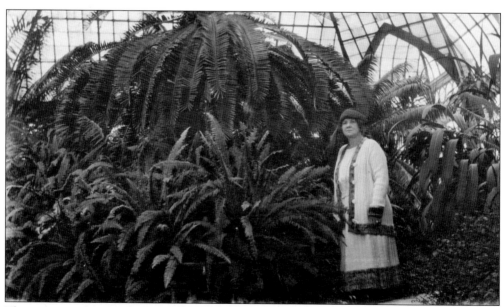

This woman is shown visiting the Buffalo and Erie County Botanical Gardens in 1922. While not a part of Lackawanna, the gardens were a popular destination for nearby residents who could easily walk there. Indoor gardens included the Palm Dome, Dinosaur Gardens, Rainforest Garden, and Tropical Flower Garden. (Courtesy of the Buffalo and Erie County Botanical Gardens Society, Inc.)

Nine

A CULTURE
OF PATRIOTISM

Like most small American cities and towns, Lackawanna residents proudly served in the armed forces during the wars that changed American and world history: the Civil War, Spanish-American War, World War I, and World War II. After the First World War, the city honored those who made "the supreme sacrifice in service of humanity in the Great War" by planting 17 elm trees behind the library, one for each of its war dead. In 1919, returning city veterans organized the first American Legion Post in Erie County, Post No. 63.

However, it could be said that no city in the United States was more profoundly impacted by World War II than Lackawanna, New York. The national media widely reported that, per capita, Lackawanna sent more of its population into the armed services than any other city in the country. Locals cite that approximately 24 percent of the entire population (5,800 of 24,000) was in uniform. On the home front, steel production boomed at Bethlehem to support the war effort, and women were employed in great numbers to fill depleted work ranks. To support their loved ones in uniform, citizens sacrificed as well with blackouts, scrap metal drives, food rationing, curfews, civil defense corps, and exceeding war bond quotas.

The calamity of war had Lackawannans meeting in basic training, staging areas, battlefields, and evacuation hospitals all over the European and Pacific theaters of operation. Most tragically, 104 of Lackawanna's finest gave their lives in freedom's cause. The losses were extraordinarily devastating to the close-knit community that seemed to be hosting a continuous funeral. Freedom is not free, and Lackawanna dearly paid the price.

After the war, veterans organized to remember their fallen comrades and share their common experiences in service. Newly chartered veterans organizations and women's auxiliaries included the Col. John B. Weber VFW Post 898, the Matthew Glab American Legion Post 1477, the Bett-Toomey Marine Corps League, the US Coast Guard League, and the Bethlehem Park Veterans Association, and disabled veterans joined the existing American Legion Post No. 63.

In every way possible, this city exemplified the saying "all gave some and some gave all."

SOUVENIR

Dedication Cermonies

MEMORIAL BUILDING

SATURDAY, APRIL FIFTH
NINETEEN HUNDRED TWENTY-FOUR
LACKAWANNA - - - - NEW YORK

In April 1919, veterans of World War I organized to become one of the first posts of the American Legion. By May 15, 1919, eighty-four members had signed the application for a charter. The official American Legion Charter was received on June 11, 1919. The Memorial Hall, the post's first formal building, was dedicated in April 1924. (Photograph by Charles D. Curtin, courtesy of American Legion Post No. 63.)

Proud citizens along with uniformed veterans salute parading servicemen in front of Memorial Hall. Additional veterans organizations that have served Lackawanna are the John B. Weber Post of the Veterans of Foreign Wars, the Matthew Glab Post No. 1477, chartered in 1947, and the Bett-Toomey Detachment of the Marine Corps League, organized in 1949. (Courtesy of the Lackawanna Public Library.)

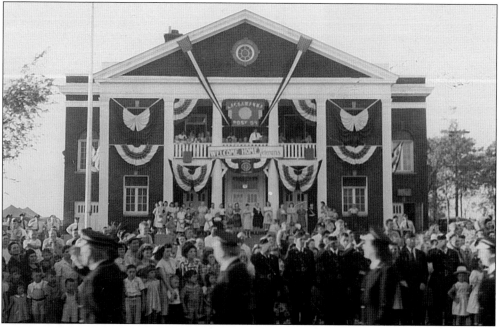

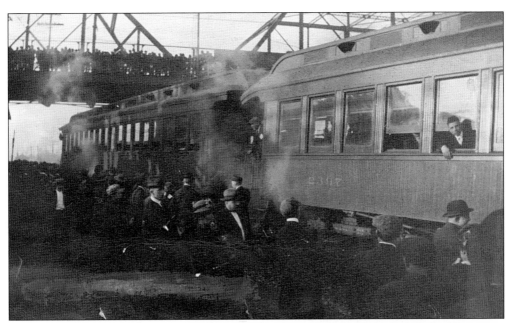

Large crowds gather on the bridge across the railroad tracks on Ridge Road to send newly enlisted servicemen for duty in World War I. The citizens of Lackawanna worked unceasingly to produce the steel for armaments and with deep patriotic fervor sent their priceless sons in defense of the nation's freedom. This train is shown at the Lake Shore Depot in 1917. (Courtesy of American Legion Post No. 63.)

Steve Ostrich, an ethnic Serb who emigrated from the Austro-Hungarian Empire to Lackawanna, was honorably discharged from the US Army on July 25, 1919, after his first enlistment period. He was inducted on November 8, 1917, in Lackawanna, New York. Ironically, the constant nationalistic warfare was exactly one of the reasons Ostrich left Europe. (Courtesy of Nicholas D. Korach.)

Honorable Discharge from The United States Army

TO ALL WHOM IT MAY CONCERN:

This is to Certify, That Steve Ostrich. 2414743

Private Company H. 36th Infantry.

THE UNITED STATES ARMY, as a Testimonial of Honest and Faithful Service is hereby Honorably Discharged from the military service of the United States by reason of Expiration Term of Service per S.O.

Said Steve Ostrich was born in Belgram, in the State of Austria. When enlisted he was 22 years of age and by occupation a Laborer. He had Bay eyes, Brown hair, Dark complexion, and was five feet 10 inches in height. Given under my hand at this 25th day of June, one thousand nine hundred and nineteen.

Commanding.

Form No. 525, A. G. O.

121

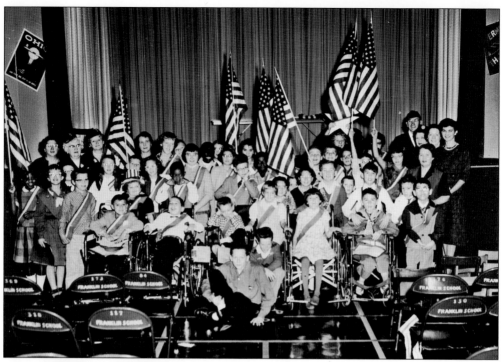

American Legion Post No. 63 was known for its participation in civic and patriotic events in Lackawanna. During World War II in the Memorial Hall, the post sponsored social events and farewells for departing servicemen. This photograph shows a celebration of a Flag Day party for children with disabilities at the Franklin School. (Photograph by Charles D. Curtin, courtesy of American Legion Post No. 63.)

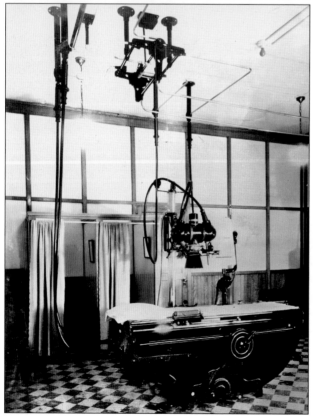

Even with the effects of the Great Depression still being felt, the charitable efforts of the American Legion attempted to reach all citizens of Lackawanna. In 1941, post No. 63 raised $10,000 for this X-ray machine, table, and accessory equipment for donation to Our Lady of Victory Hospital. (Photograph by Charles D. Curtin, courtesy of American Legion Post No. 63.)

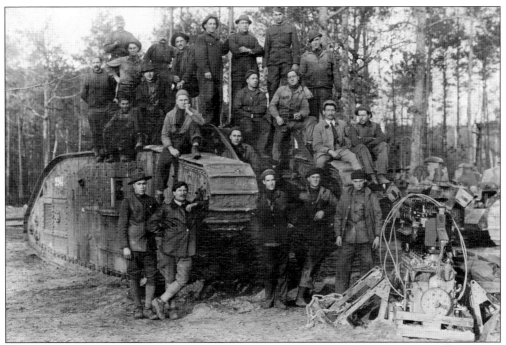

The rise in the use of armor plating for military applications certainly contributed to the growth of the iron and steel industries throughout the world. This diverse group of unidentified soldiers is gathered around a British tank during World War I. (Courtesy of American Legion Post No. 63.)

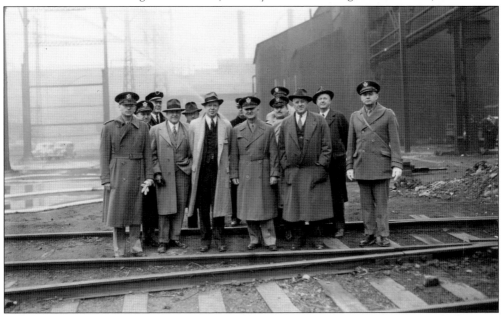

Worldwide economic depressions and wars stressed the steel industry in the United States. Production of war-related material diminished the natural resources of the nation. For Bethlehem Steel Corporation, this was reflected in the coalfields of the Mesabi Range. This visit to Bethlehem Steel's Lackawanna plant by military officials took place on April 21, 1943. (Courtesy of the Steel Plant Museum of Western New York.)

T.Sgt. Bernard Budimirovich left Canisius College, in Buffalo, New York, to serve in the US Army Air Corps as an aerial gunner in the 429th Bomb Squadron, 2nd Bomb Group, Eighth Air Force. Bernard died in service to his country on February 19, 1943. (Courtesy of Nicholas D. Korach.)

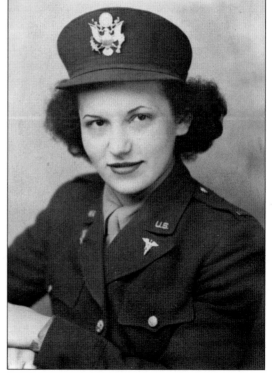

Lt. Mildred Budimirovich was a member of the US Army Nurse Corps. As a registered nurse, she was assigned to the 96th Evacuation Hospital. During her military career, Mildred served in England, Utah Beach, France, Belgium, and Germany and was awarded five battle stars. (Courtesy of Nicholas D. Korach.)

Even in the midst of war, small miracles can happen. One such event is a chance meeting of brothers stationed in the Pacific theater during World War II. On the island of Iwo Jima, two brothers from Lackawanna meet during a delivery of munitions to Marines stationed there. This photograph shows Harold Blattenberger (left) meeting his brother Del on a landing craft in 1944. (Courtesy of Harold Blattenberger.)

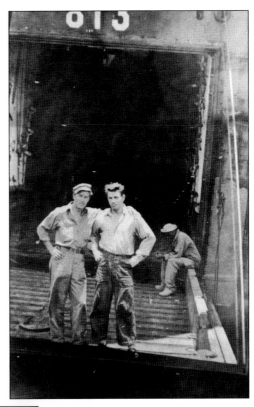

Elizabeth Rosati sent seven sons and a son-in-law off to battle during World War II. Two sons, Dominick and Daniel, paid the ultimate sacrifice. Here is a bittersweet reunion of the family heroes. They are, from left to right, (first row) Frank Rosati, John Rosati and Louis Patrucci; (second row) Albert Rosati, Anthony Rosati, and Fred Rosati. (Courtesy of John Rosati.)

Gold Star mothers are shown being escorted from their Annual Memorial Mass at Our Lady of Victory Shrine in May 1948. This procession would continue on to the American Legion Post No. 63 Club Room in the Memorial Building. The guests would then be honored with their annual banquet hosted by the American Legion Auxiliary. (Photograph by Charles D. Curtin, courtesy of American Legion Post No. 63.)

Post No. 63 Drum Corps Champions were the city of Lackawanna's goodwill ambassadors to many cities in the United States and Canada. Here, they are shown parading in Chicago, Illinois, at the American Legion National Convention. There are 50 drum corps members and 30 delegates of the post marching with them. Featured is drum major Franks Owens. (Photograph by Charles D. Curtin, courtesy of American Legion Post No. 63.)

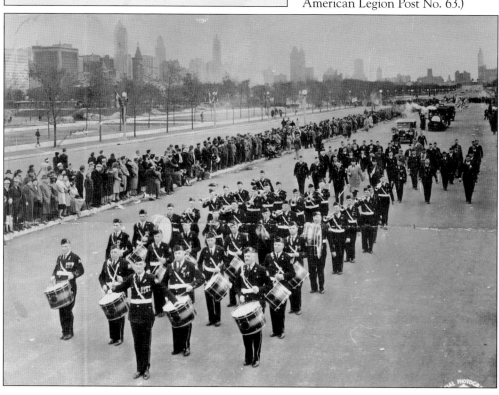

BIBLIOGRAPHY

Centennial Anniversary Edition. *1909–2009: Lackawanna, New York.* Lackawanna, NY: City of Lackawanna Centennial Committee, 2009.

Emerling, William H. and John P. Osborne. *The History of Lackawanna.* Lackawanna, NY: City of Lackawanna Bicentennial Commission, 1976.

Fitch, John A. *The Human Side of Large Outputs/Lackawanna-Swamp, Mill, and Town.* The Survey. Volume 27 (October 1911–March 1912). New York: The Charity Organization Society.

Koerner, John. *The Father Baker Code.* Buffalo, NY: Western New York Wares, 2009.

———. *The Mysteries of Father Baker.* Buffalo, NY: Western New York Wares, 2005.

Leary, Thomas E. and Elizabeth C. Scholes. *From Fire to Rust.* Buffalo, NY: Buffalo and Erie County Historical Society, 1987.

Lillis, Romaine, ed., the Lackawanna Historical Association. *Echoes of Lackawanna: 1909–2009.* Lackawanna, NY: Morris Publishing, 1997.

www.arcadiapublishing.com

Discover books about the town where you grew up, the cities where your friends and families live, the town where your parents met, or even that retirement spot you've been dreaming about. Our Web site provides history lovers with exclusive deals, advanced notification about new titles, e-mail alerts of author events, and much more.

Find Your Place in History.